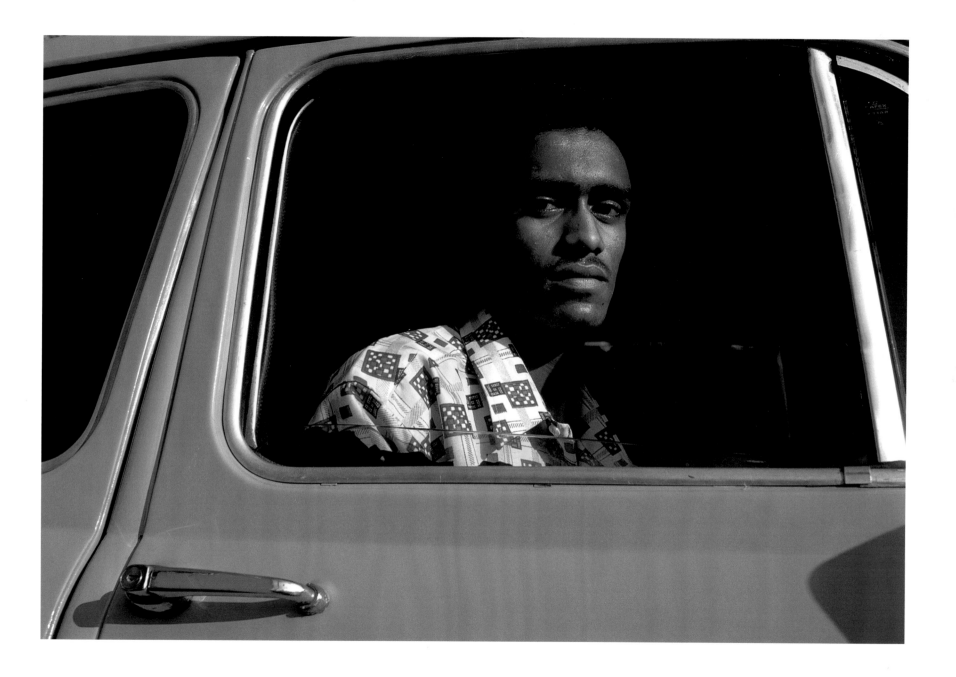

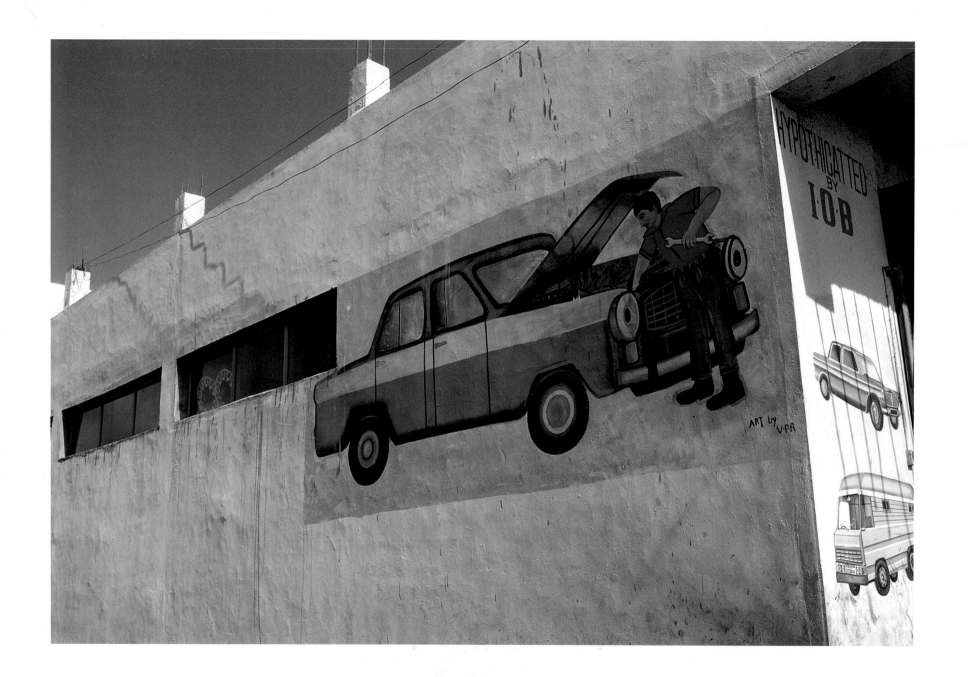

A Way into India | Raghubir Singh

A Way into India

For thirty years I have travelled in hired Ambassador cars. As I journeyed all over India I came to understand that if one thing can be singled out to stand for the past fifty years of India and its closed economy, now open and moving into the new millennium, it has to be the Ambassador. And I would say, the White Ambassador, as this is the most common colour on the Ambassadorized roads of India: white being the colour of piety and purity in the religions of Asia. Black is a taboo colour and so black ones are rare, although sometimes used by the wicked: in Calcutta for instance, *dacoits* (members of armed gangs) have used them to help merge with the darkness of the night.

I describe below the White Ambassador, as I saw it, under a banyan tree one day, while I waited for the driver to check the wiring and the engine after a mesmerizing monsoon downpour. It was no longer absolutely white. Mud clung to its sides, coated its fenders, and hung from the hubs and the earth-scraping parts of the frame. A bird dropping, the banyan had many a bird under its wingspan, had hit the chrome frame of a headlight. These embellishments told me that this colonial car has become a part of the Indian earth.

In doing so, it has become a metaphor for Mother India, for Independent India. Lizard-like, it has shed it's colonial coating of Morris Oxford to don Hindustani colours. Unlike the Oxford don, tweed, thick-cut marmalade and an English breakfast of kippers and herring, it was never a British monument, but it is an Indian one. It is the Hindustan Ambassador.

With body unchanged but with many different engines, it has sailed through the License Raj, the Permit Raj, the Babu Raj – all the years of pompous paperwork. All the years of denial. All the years of belt-tightened Bharat (that is to say, India). All those years, it was as if the engine hummed the tune: *Sareh Jahaan Say Achaah Yeh Hindustan Ambassdor Hamara!* All these years have made it a substantial symbol of official India. Bulletproof and tricolour fluttering, it breezes by – not just with chief ministers, minor ministers and mandarins – but with prime ministers and presidents. It is the People's Car, the Politician's Car, India's Rolls-Royce and stretch limousine all rolled into one solid, yet shaky entity. But without the official flag, without a shiny coat of paint and a uniformed driver, it is a part of another kind of India: down-to-earth India. In this aromatic Bharat, with scratches, peeling paint and homely colours, it is driven by drivers who spend the night in their cars – their odours airing the back and front seats, left and right. As this scented avatar it has become a substantial part of the unknown town and a small part of the unacknowledged village. While as a smarter avatar it is a significant part of acknowledged India, of cosmopolitan India. Except it is not part of the metropolis of Mumbai – there the Fiat Millecento has kept it at bay, in what was once Bombay.

On the other side of India in Calcutta, the second city of the erstwhile Empire that Job Charnock founded above the Bay of Bengal, it has become a kind of official carriage of the Mother Goddess and her manifold incarnations, all sculpted in Ganges clay. In the 'dying city' it is a dying car. And it is dying everywhere too! With touches of mud and clay on the outside, with sticks of incense burning inside – wisps of smoke curling over pictures of saints and gods and goddesses, jeep-like it travels our rutted routes and our terrible tracks. To keep it on its marathon track, mechanics in makeshift workshops, hoarding mounds of nuts and bolts, garlands of fan belts and clusters of spark plugs, are ready, for a handful of rupees, to clean a carburettor, soap up a leak or crab-crawl under its rusted belly – rusted like a recently dug up Chola bronze.

In the state of Kerala, it has yet another avatar. It has become an election emblem, an uplifting emblem for the quality of life that every Keralite, man and woman, quests for. In pushing past the symbols of plough and bullock and bicycle it gives us a measure of the land. It becomes a measuring rod for end-of-century India, inching into the new millennium. And yet, with roof and boot topped with bulbous baggage and inside sardine-packed with passengers, it takes us back to the march of ancient migrants, to the sway of camel caravans, to the swing of baggage elephants and to the creaky symphony of lines of lumbering bullock carts. Bullock-crawling past tile and thatch and mud, this metal monument slowly slides into history. It is now a part of India's long journey. It is an organic part of bird shit- and cow dung-coated India. It is the good and bad of India. It is a solid part of that India that moves on, even as it falls apart, or lags behind. In it's imperfection it is truly an Indian automobile.

Raghubir Singh

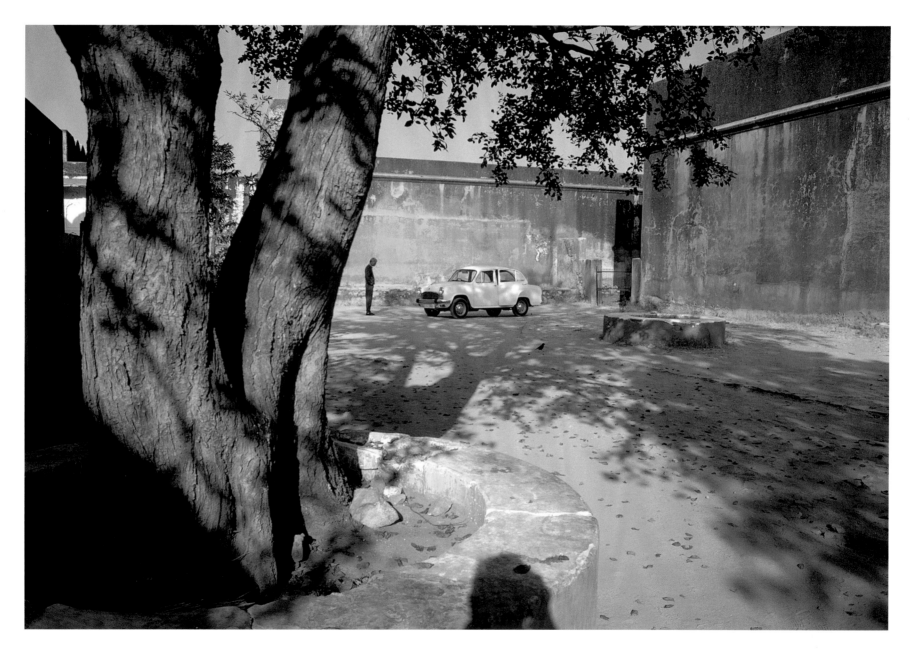

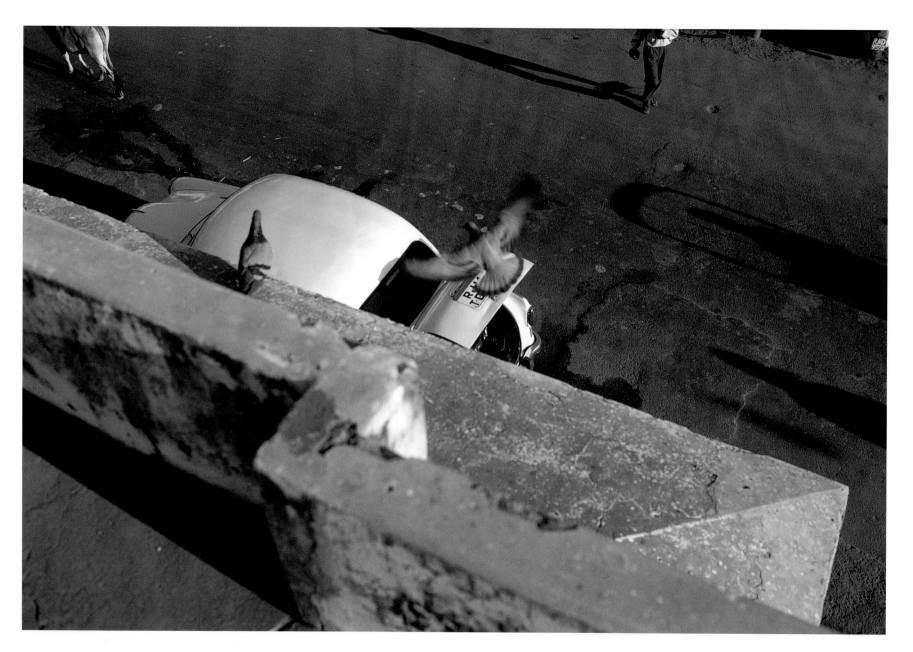

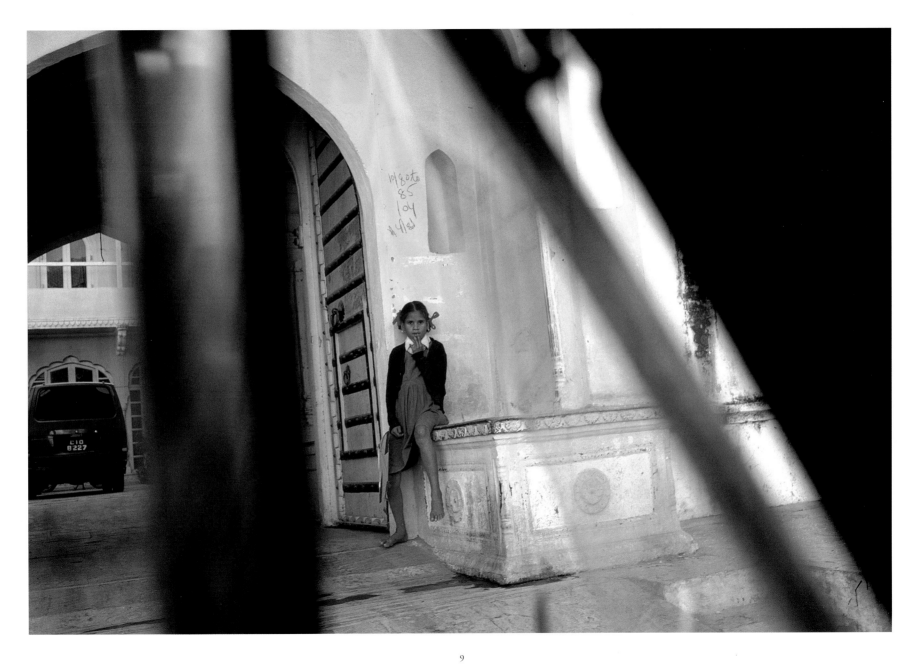

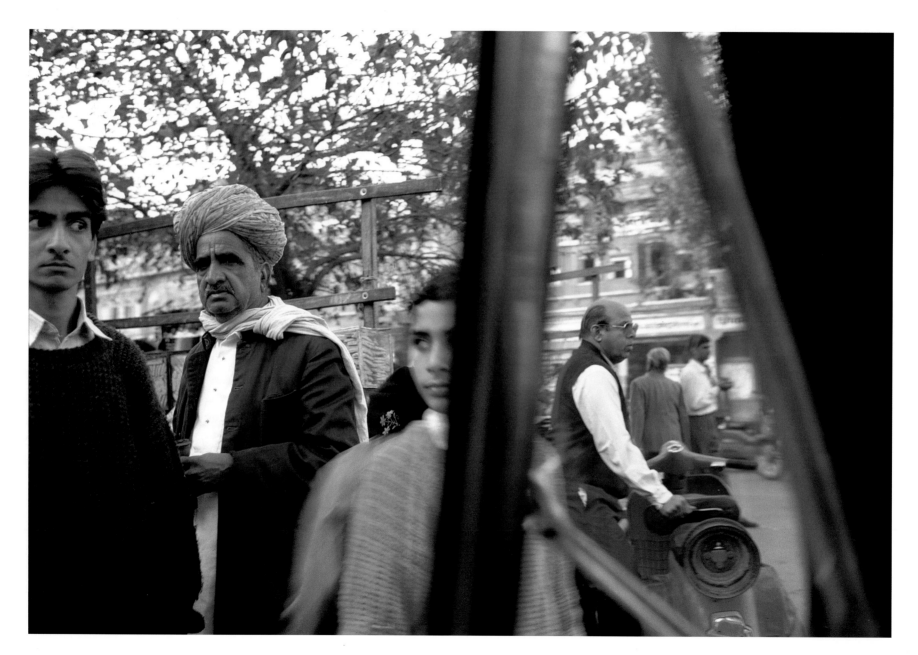

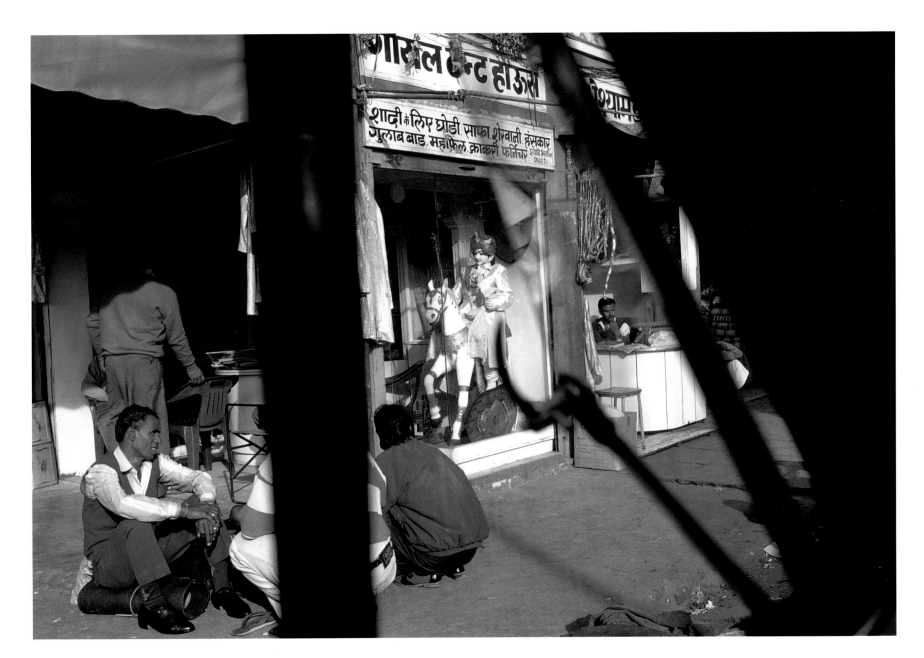

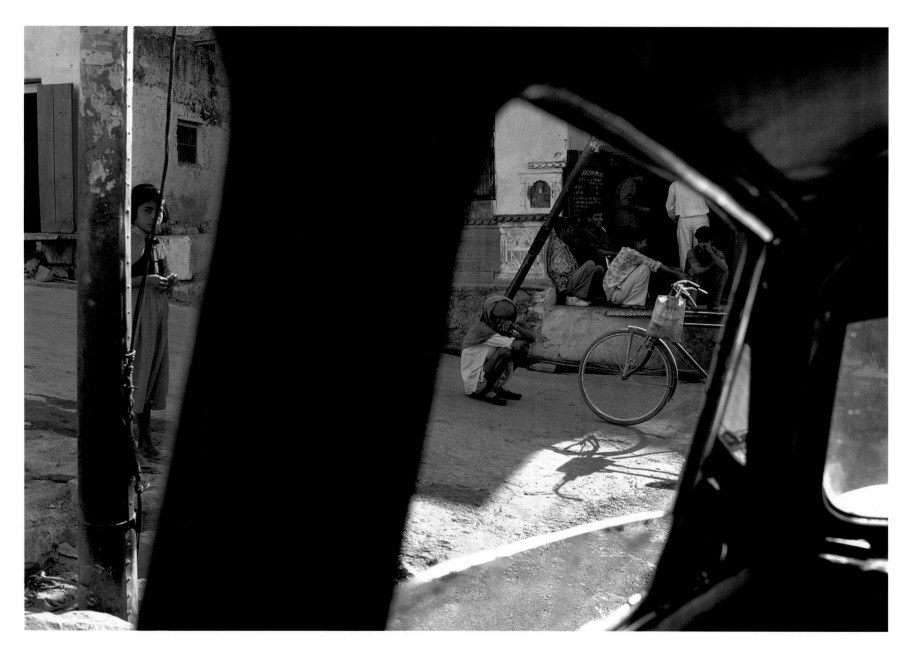

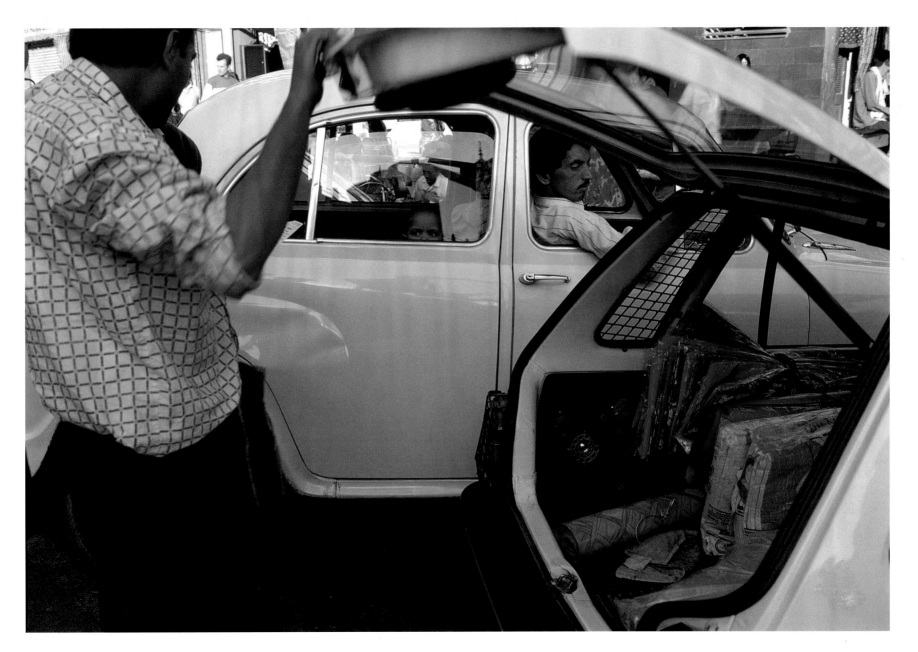

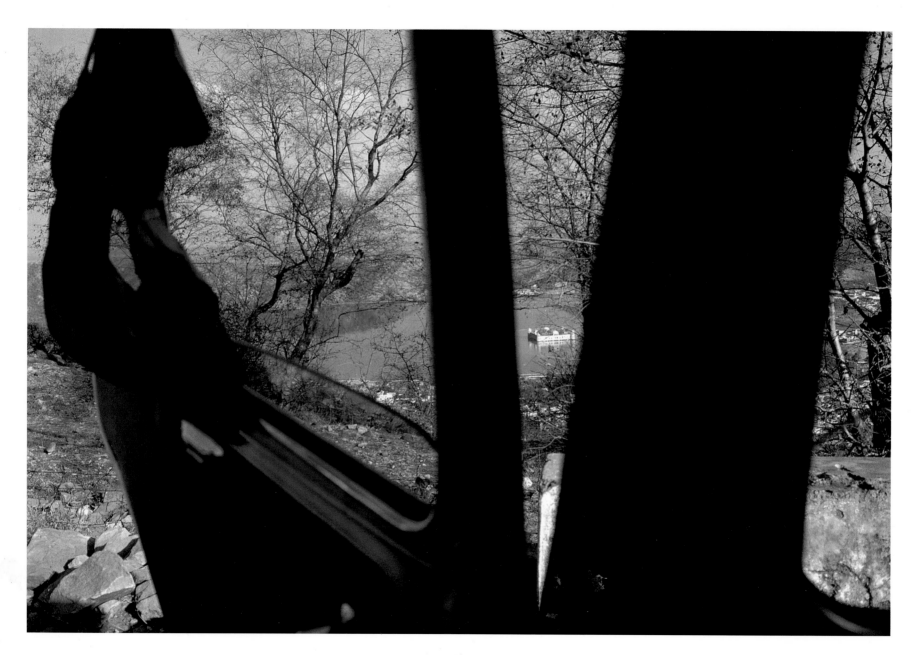

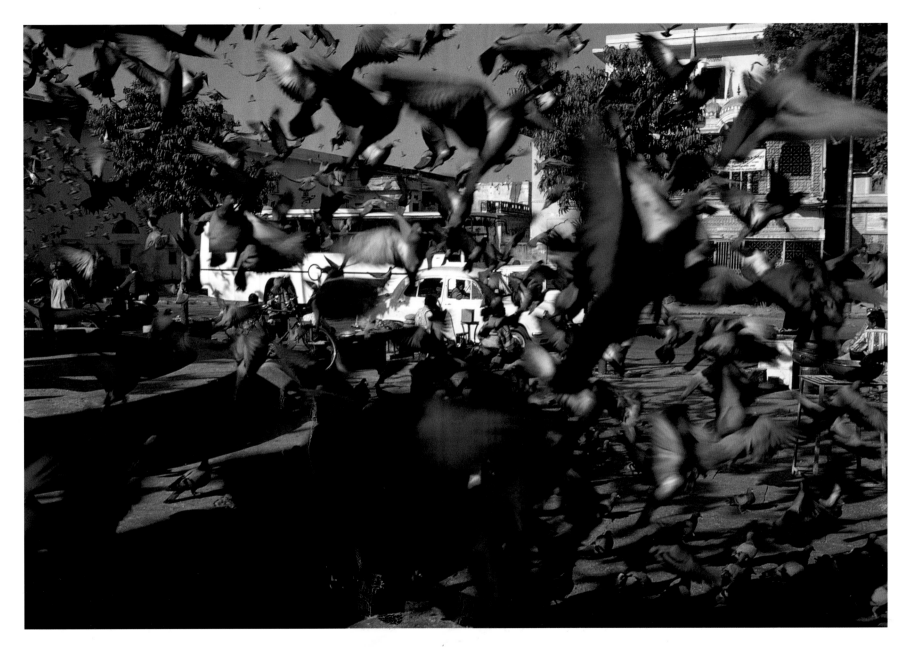

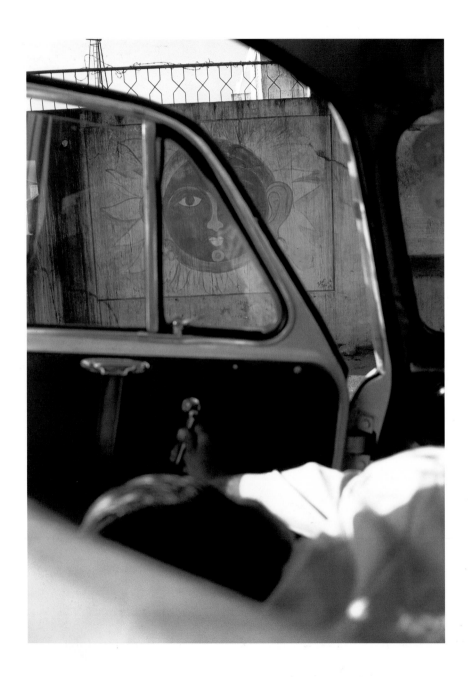

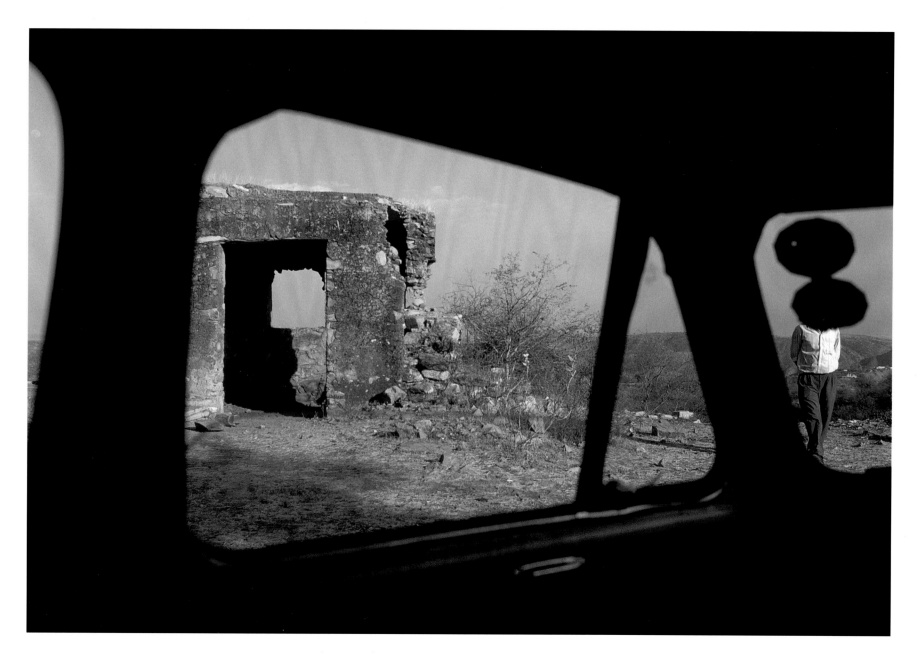

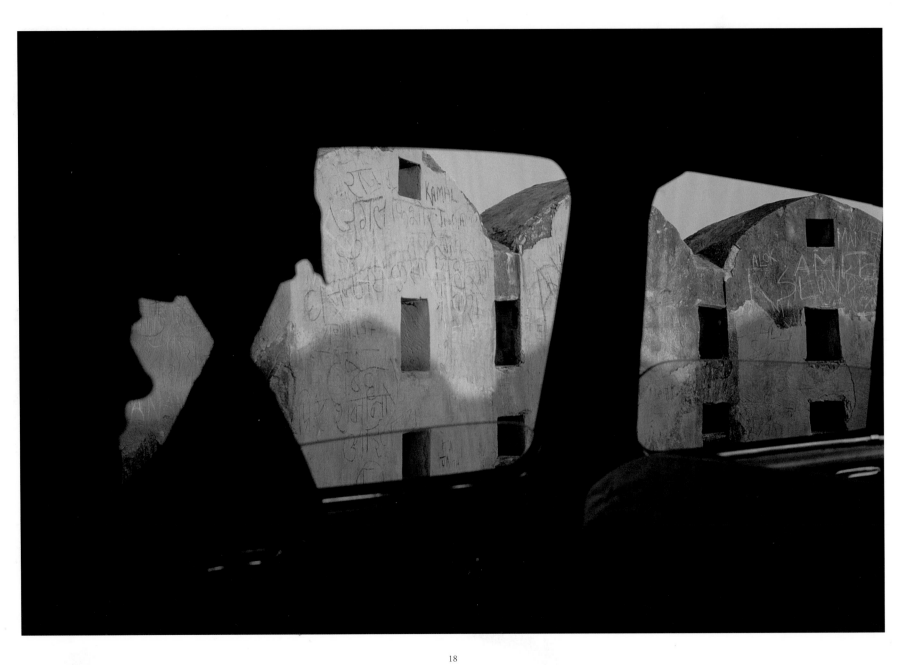

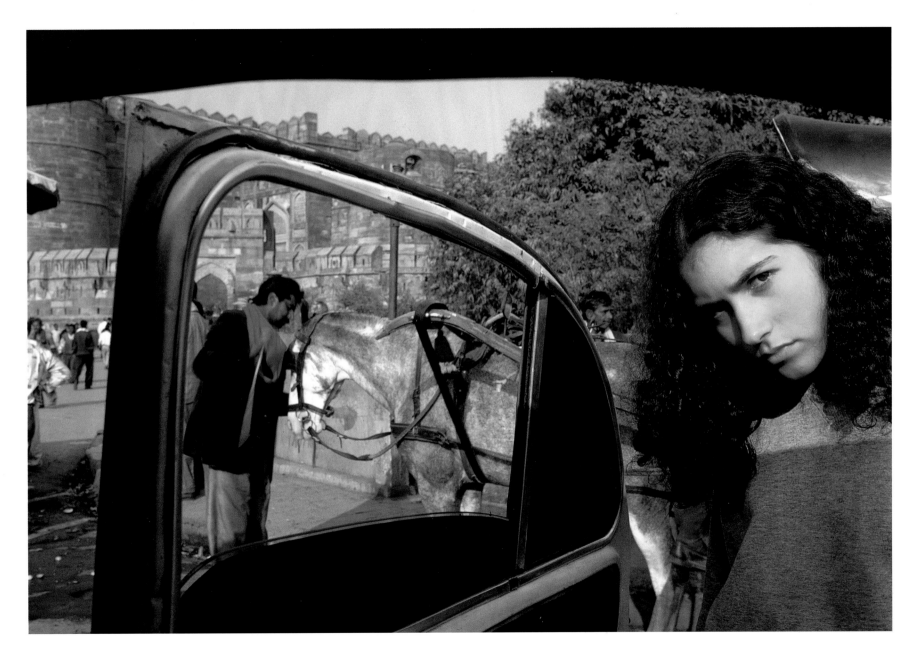

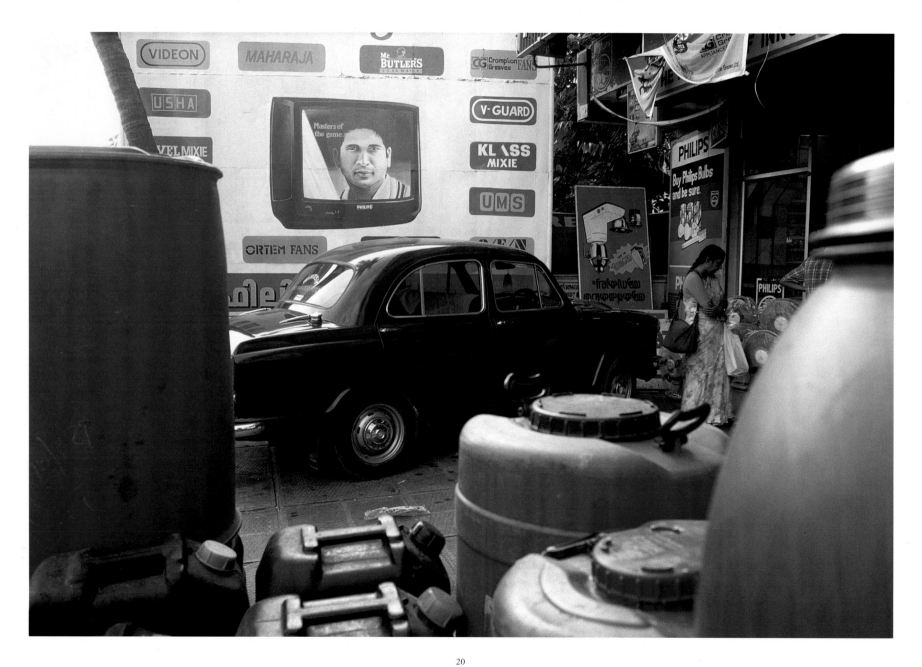

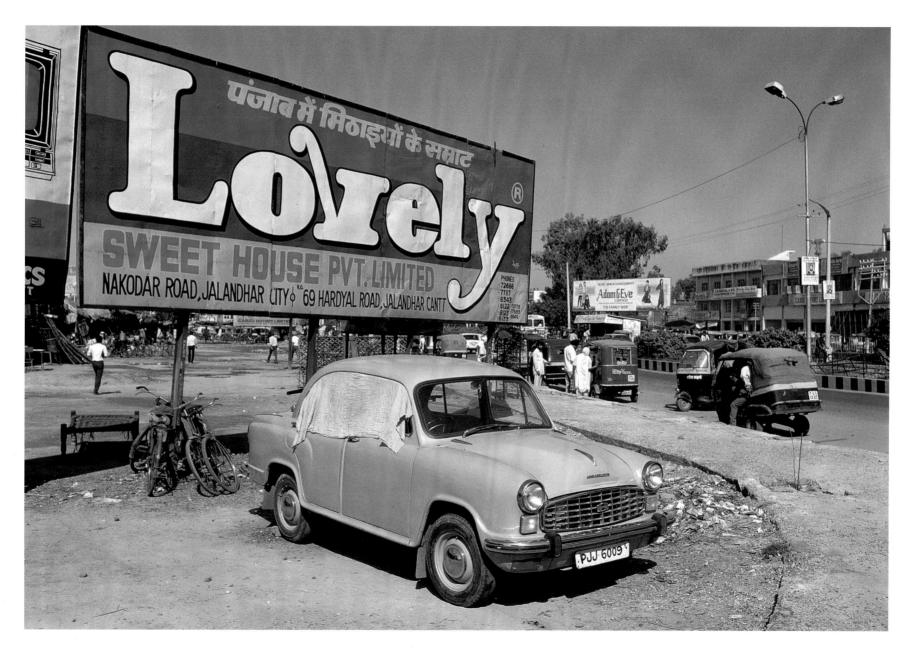

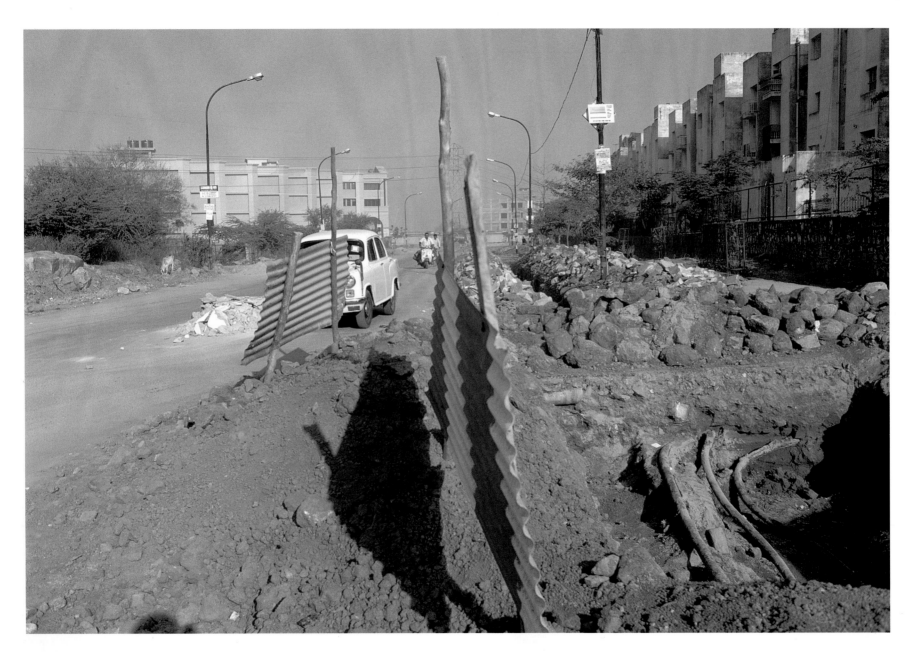

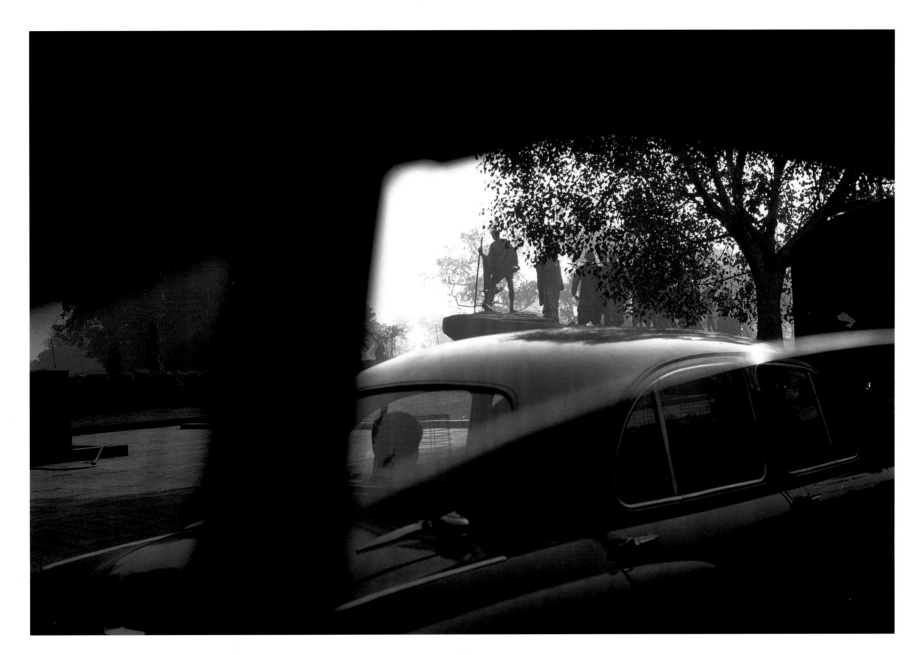

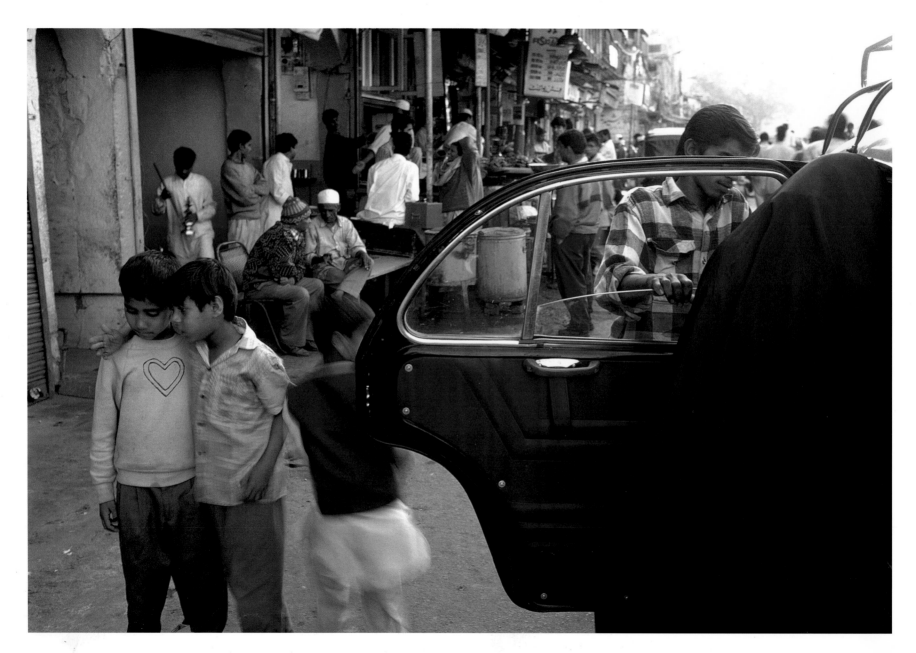

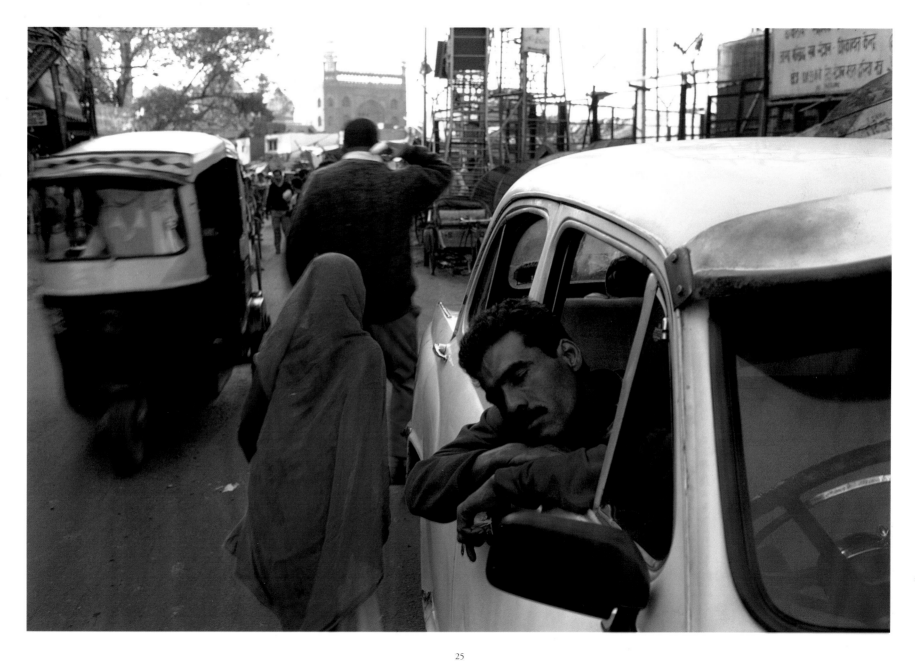

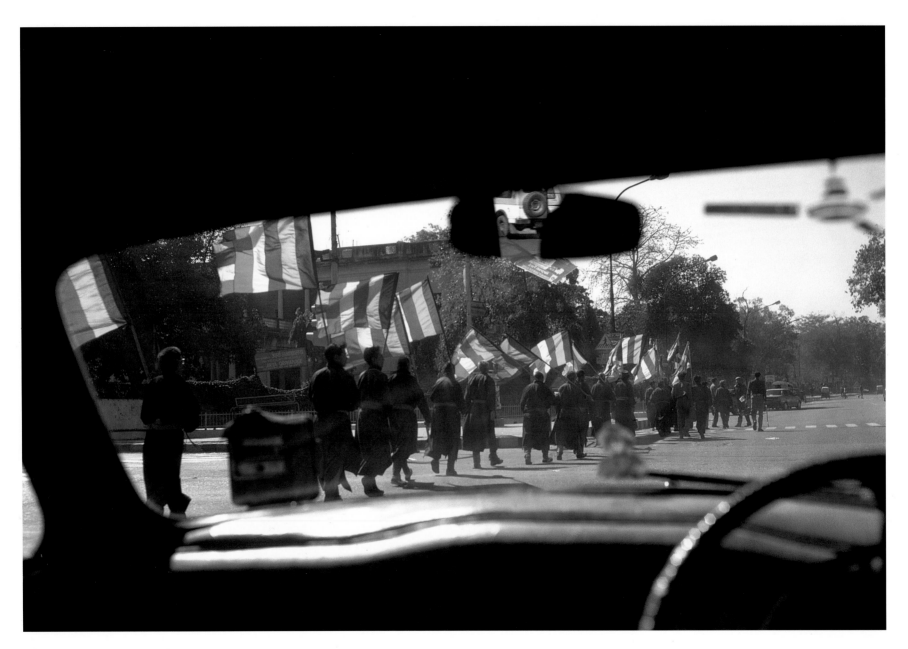

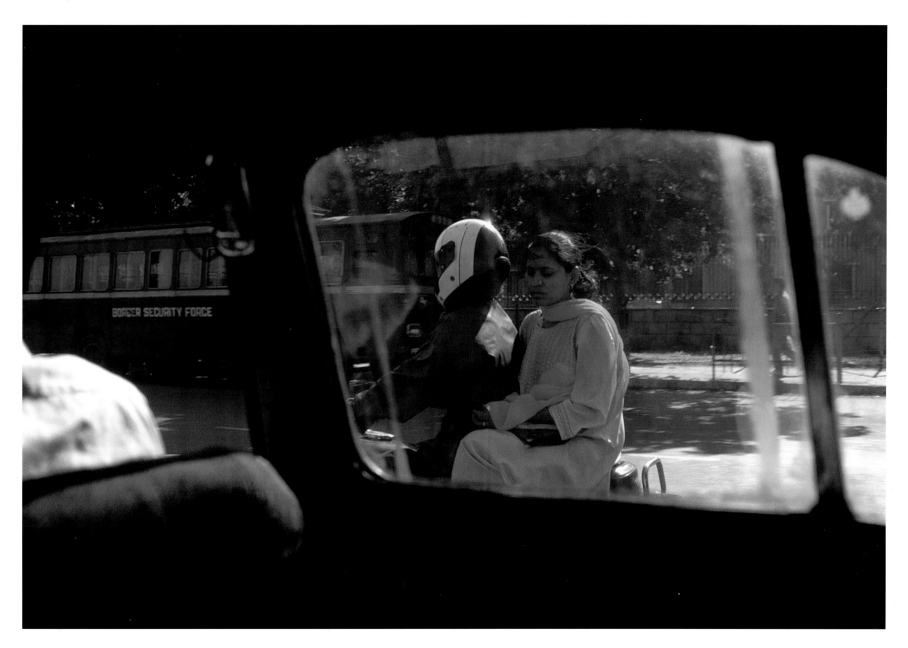

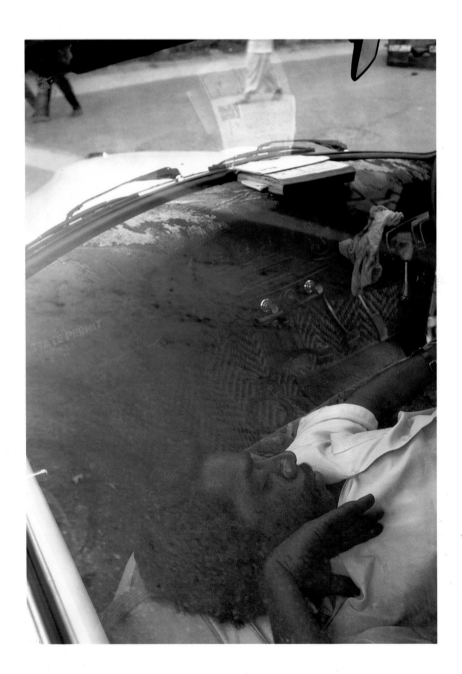

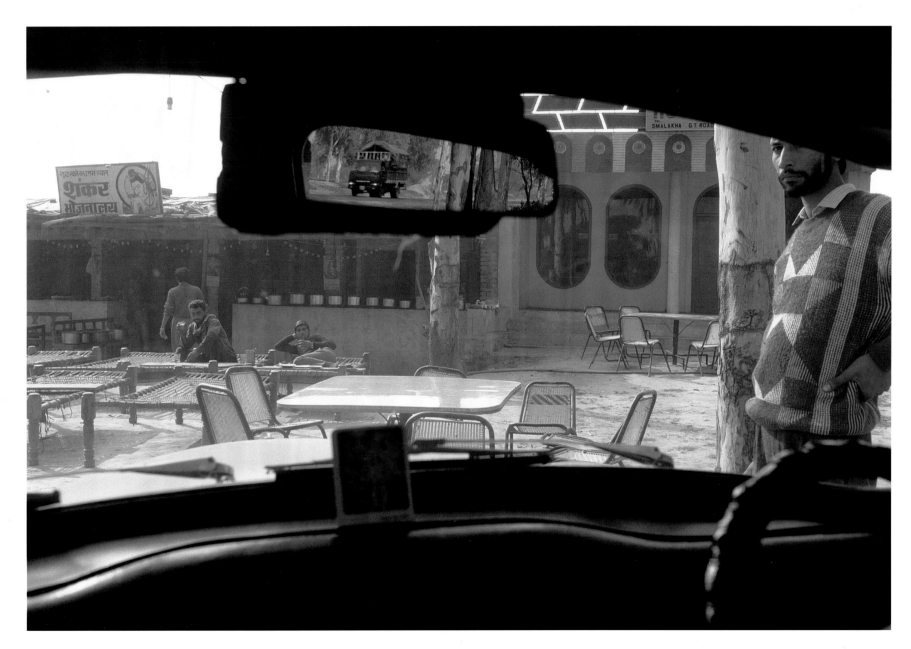

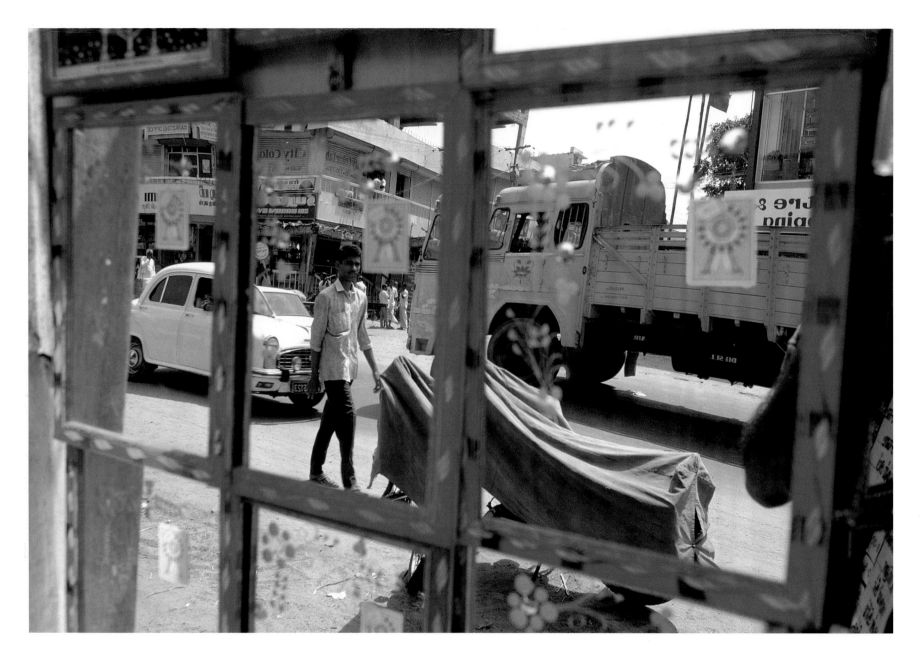

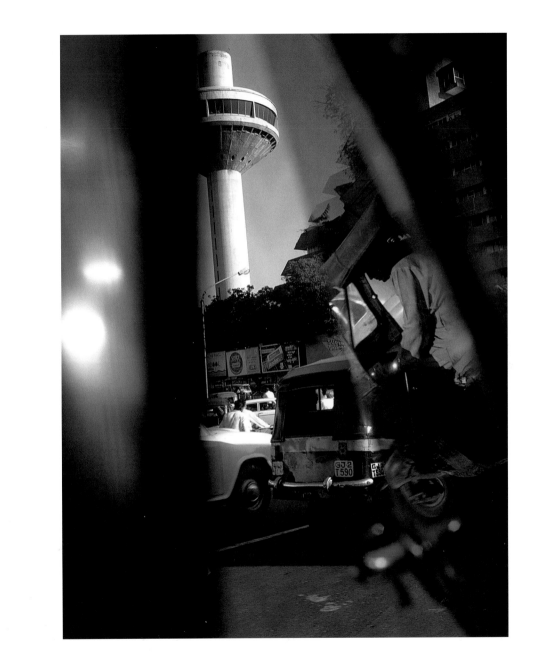

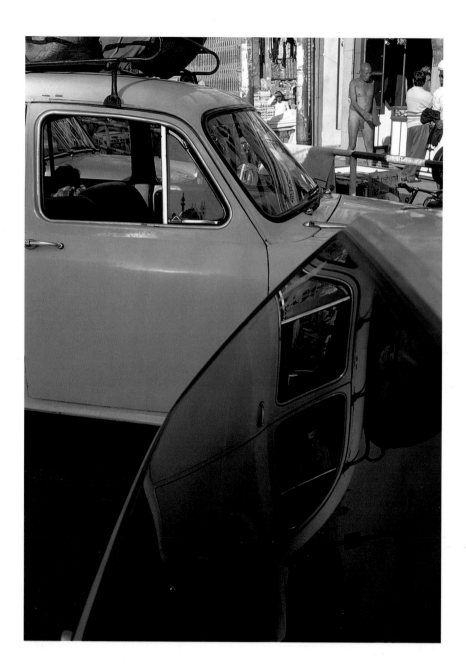

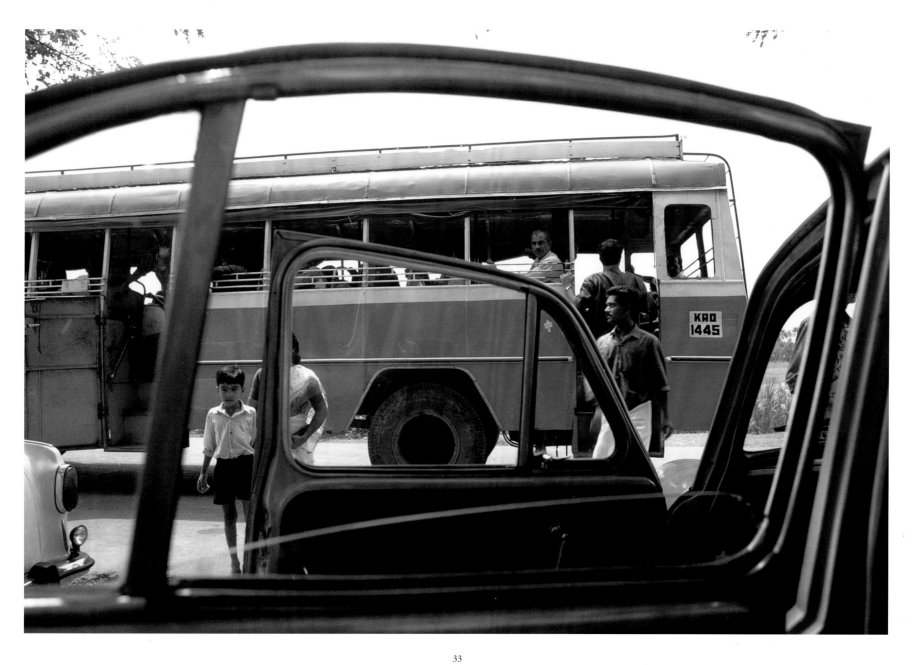

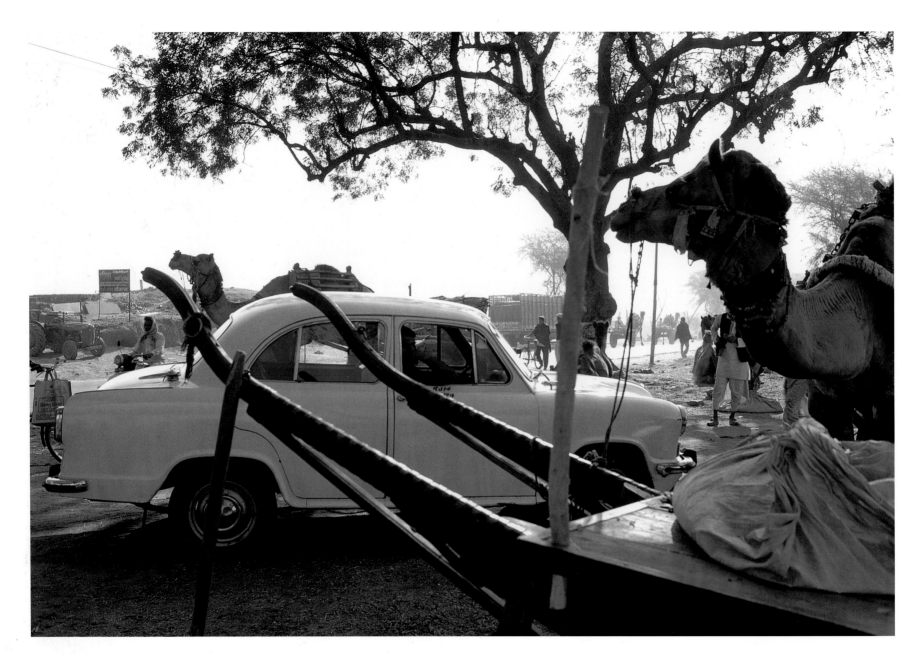

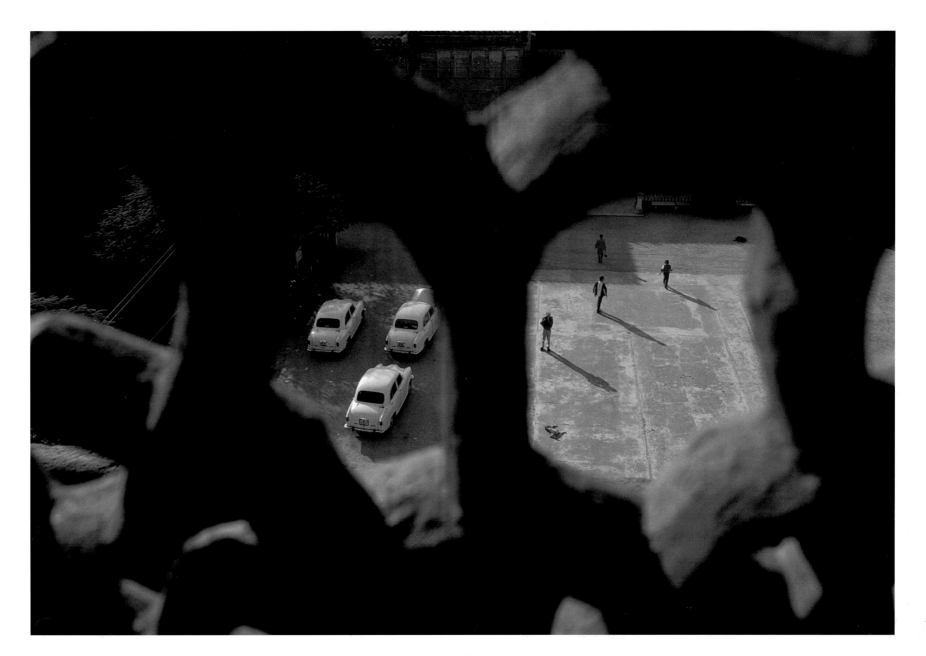

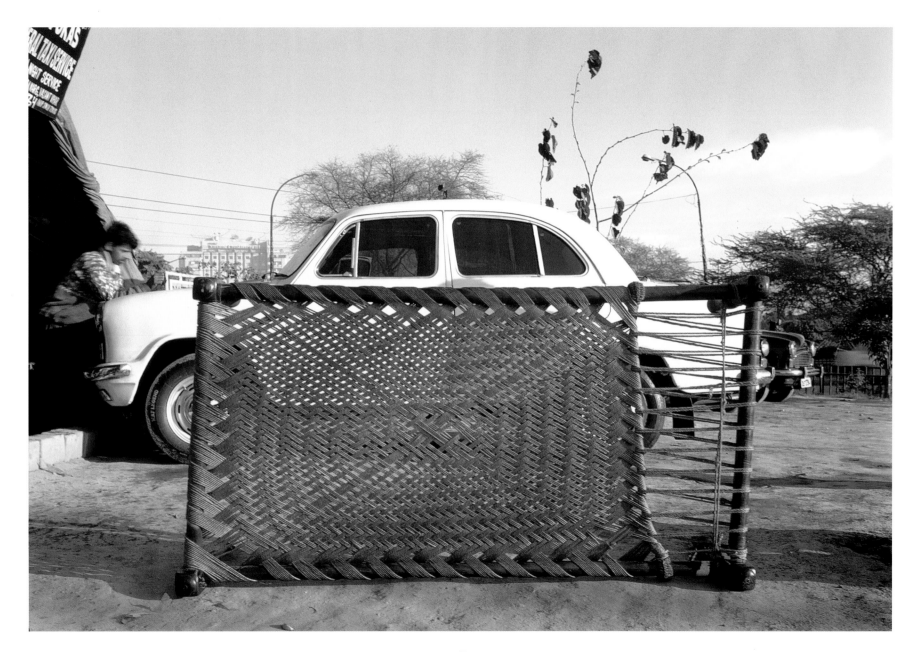

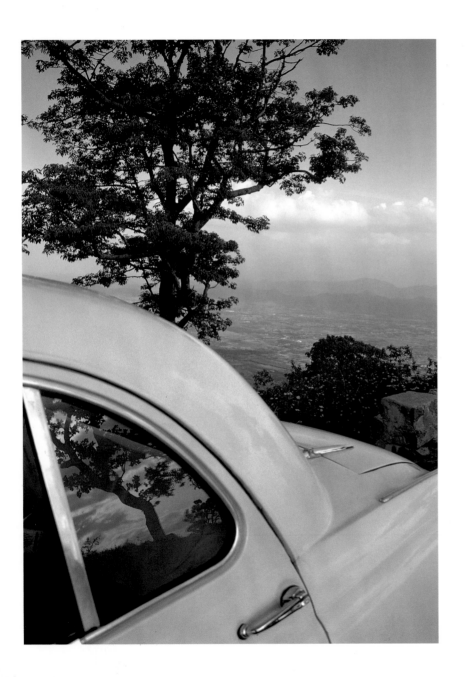

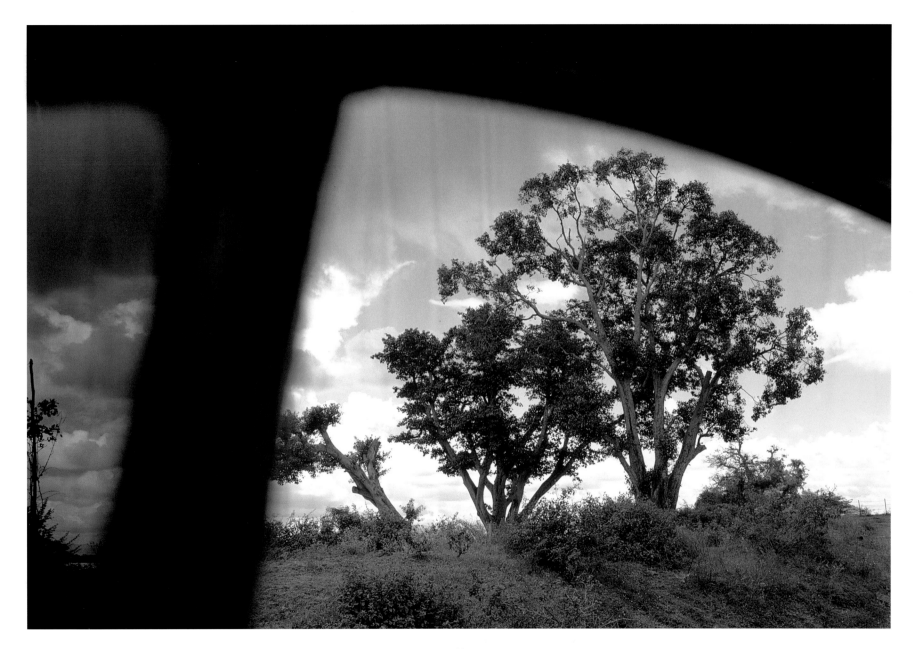

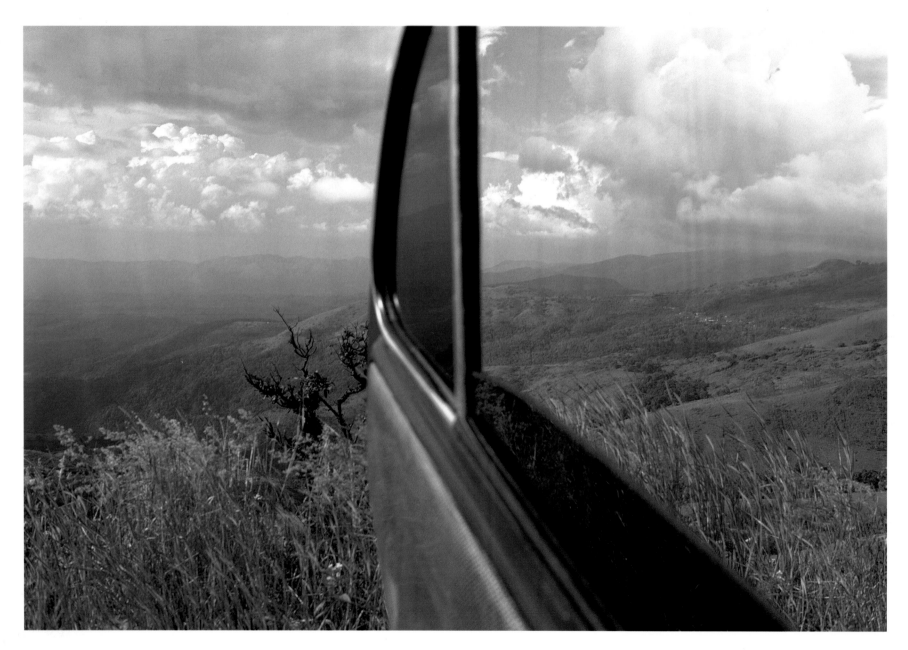

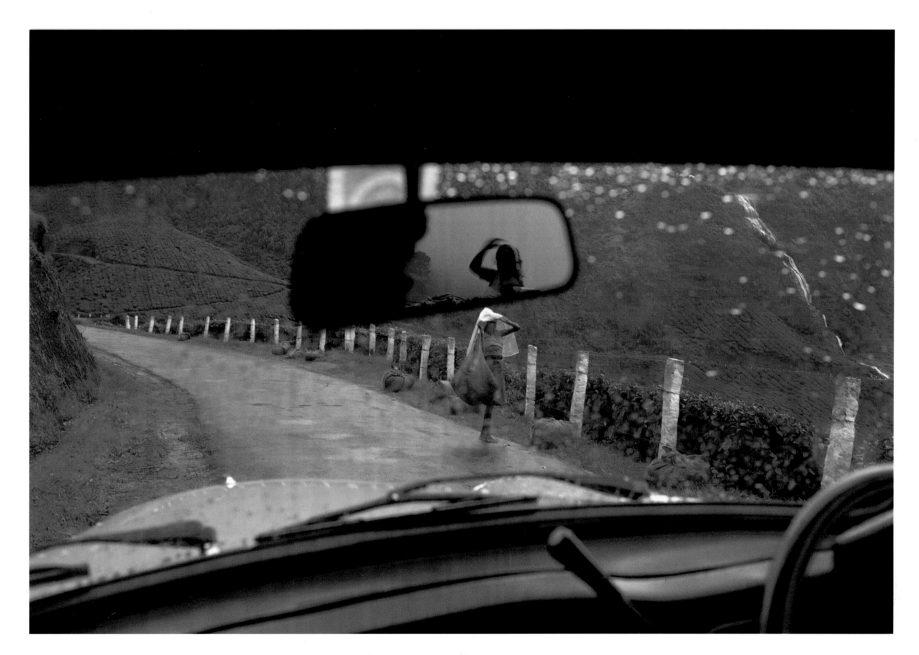

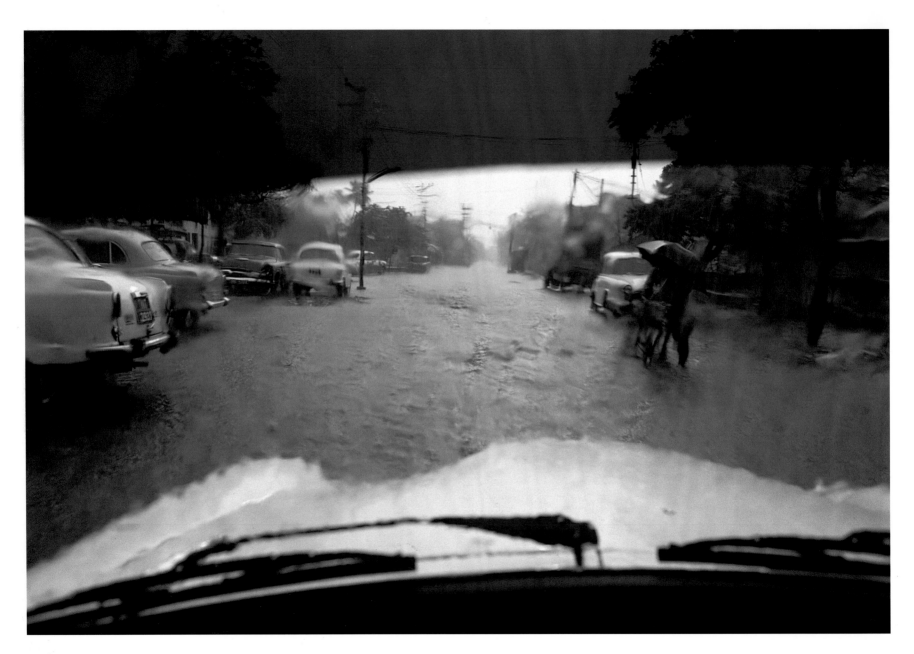

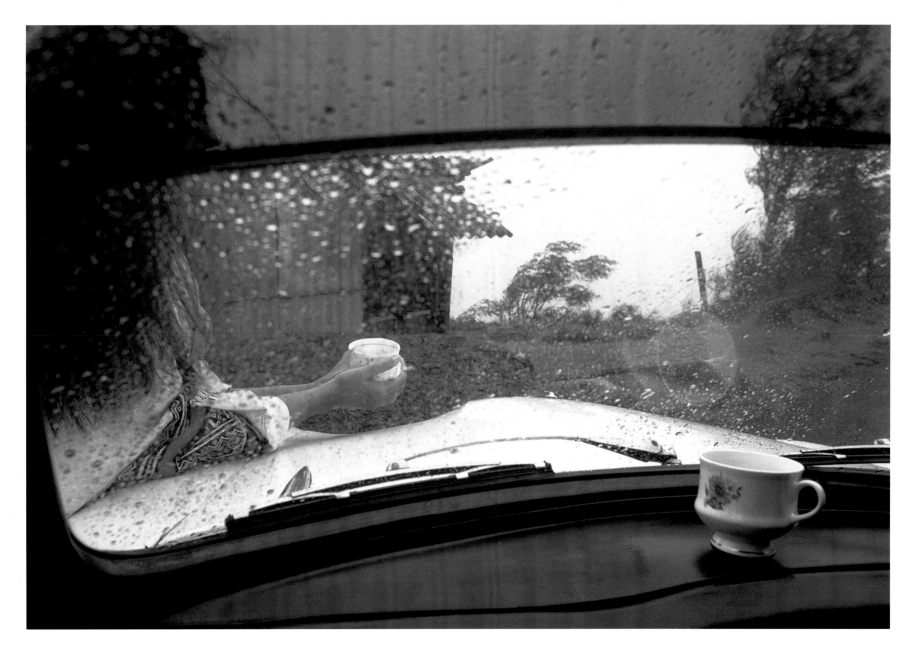

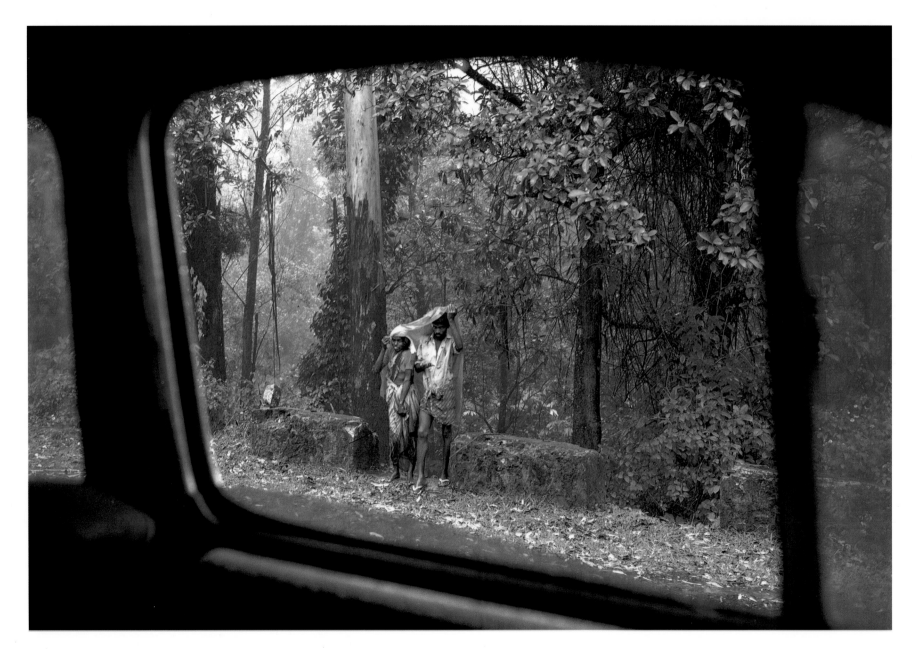

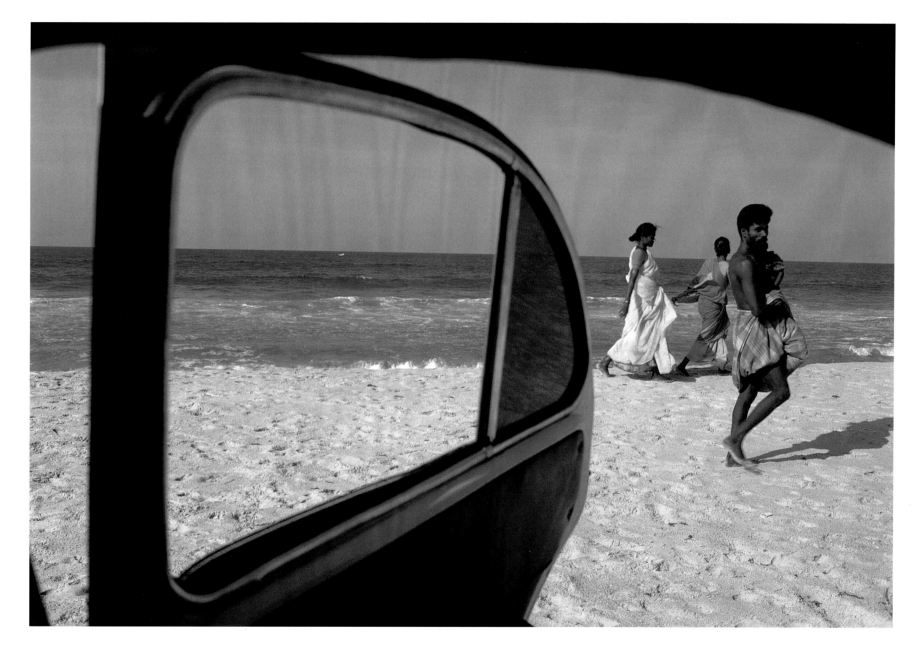

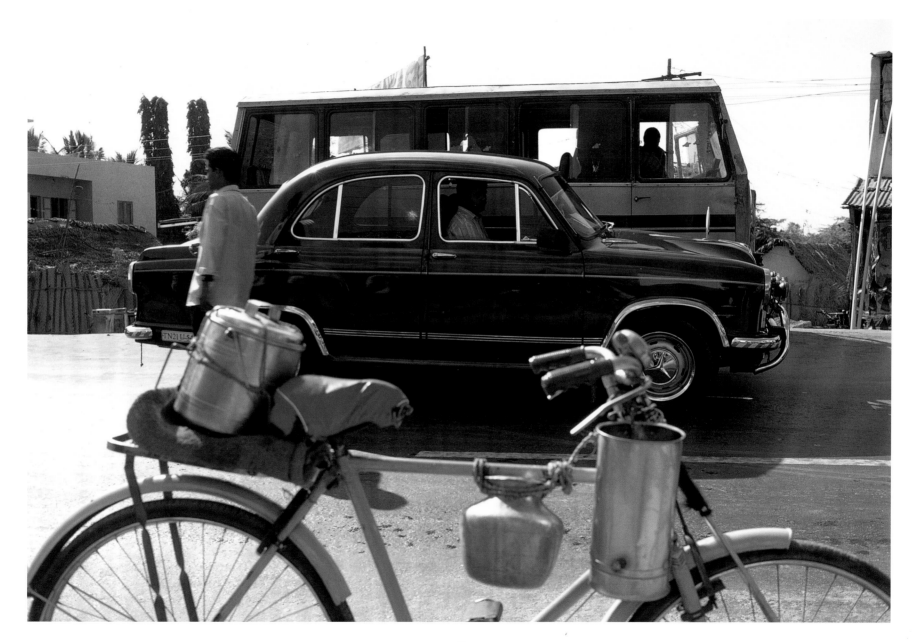

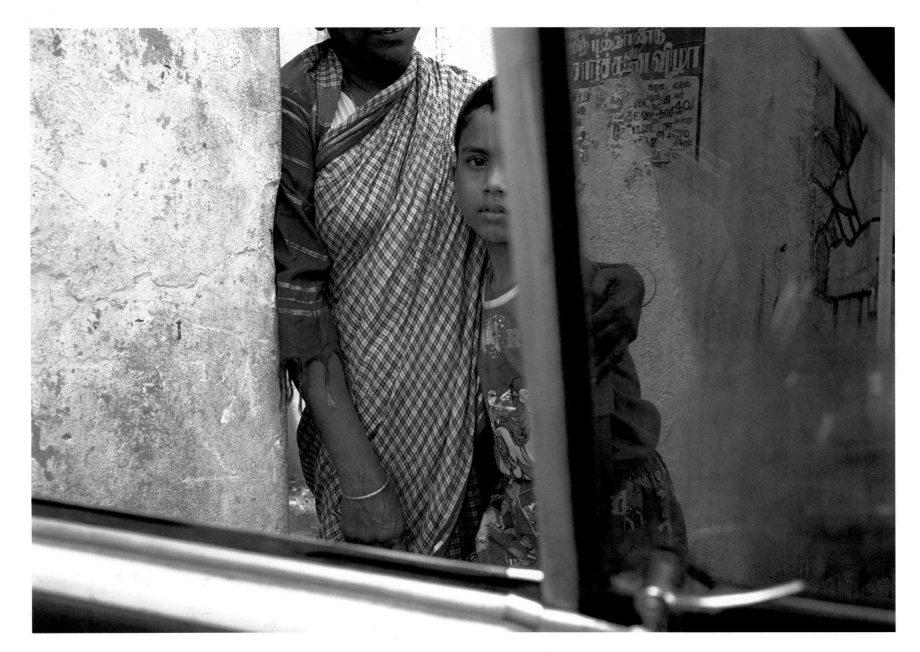

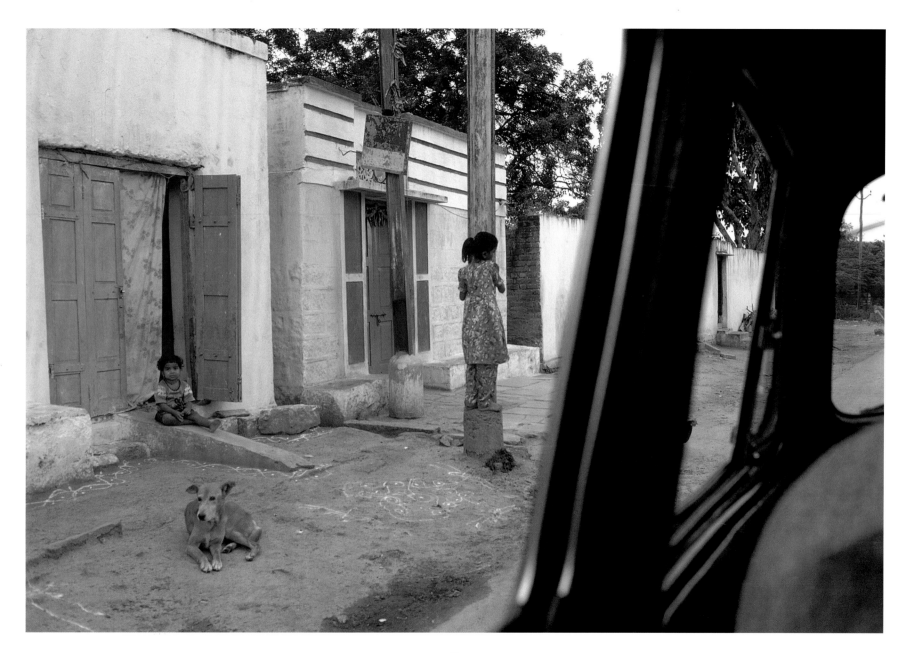

49

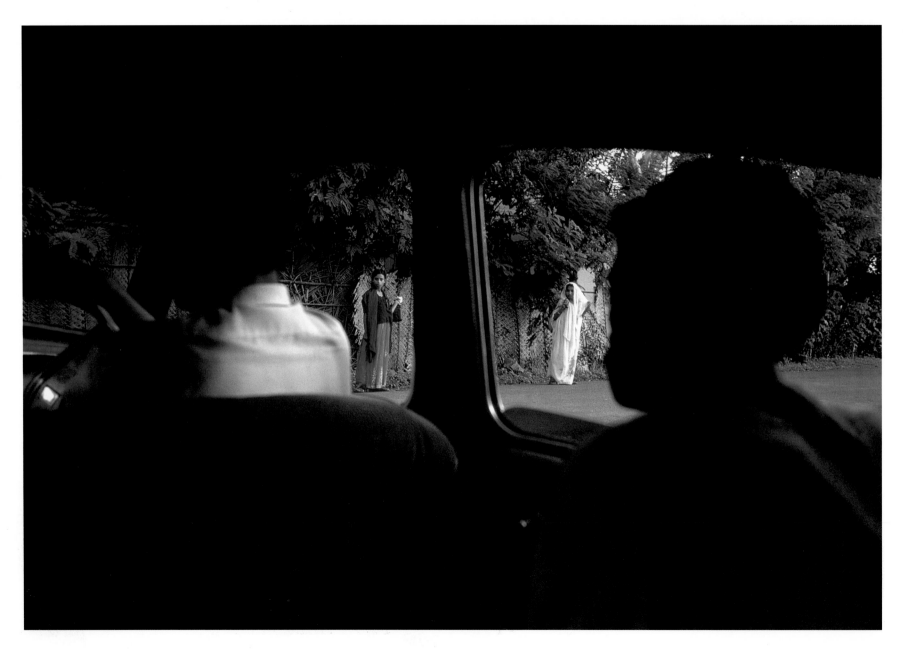

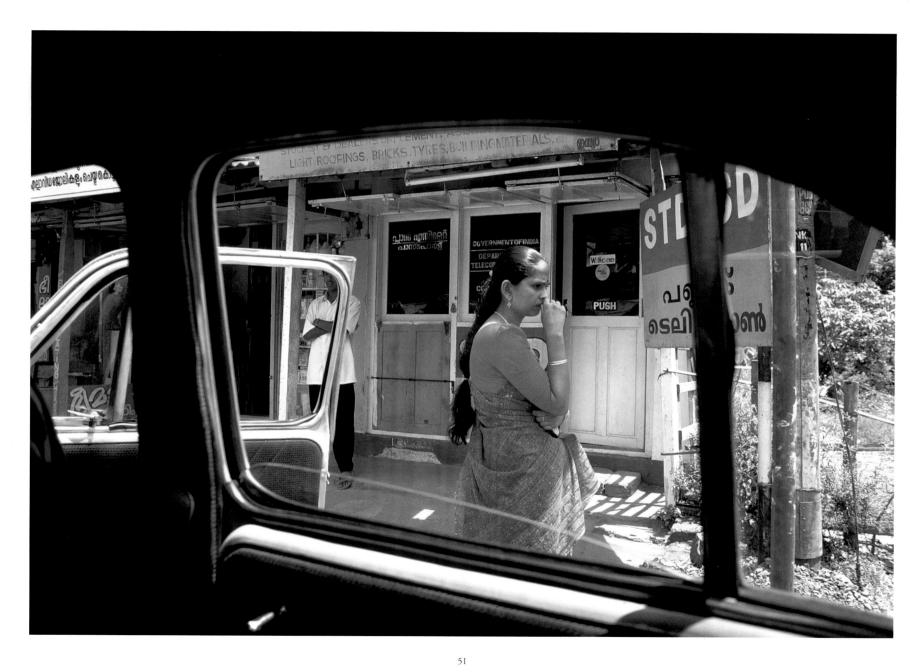

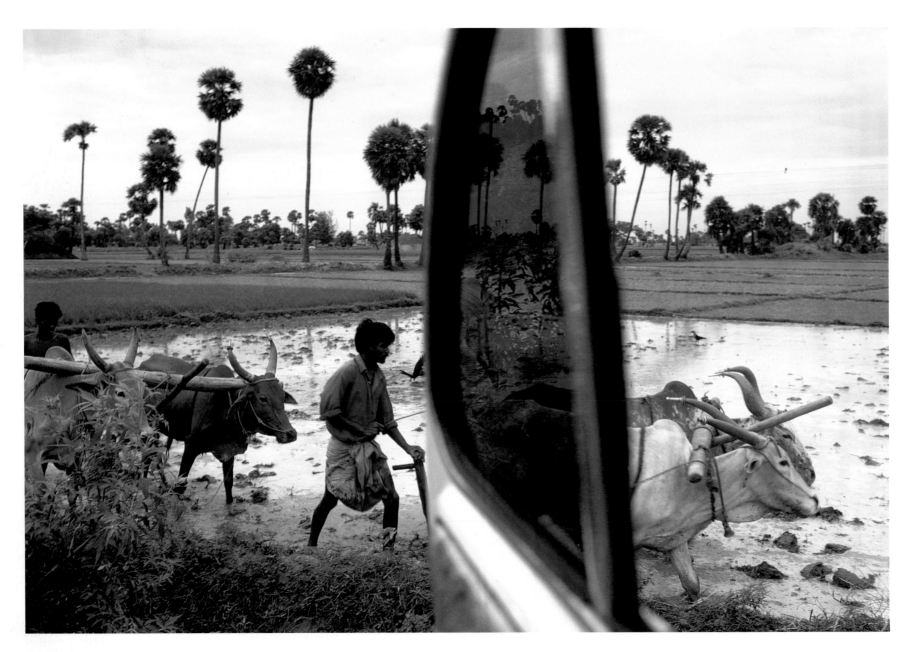

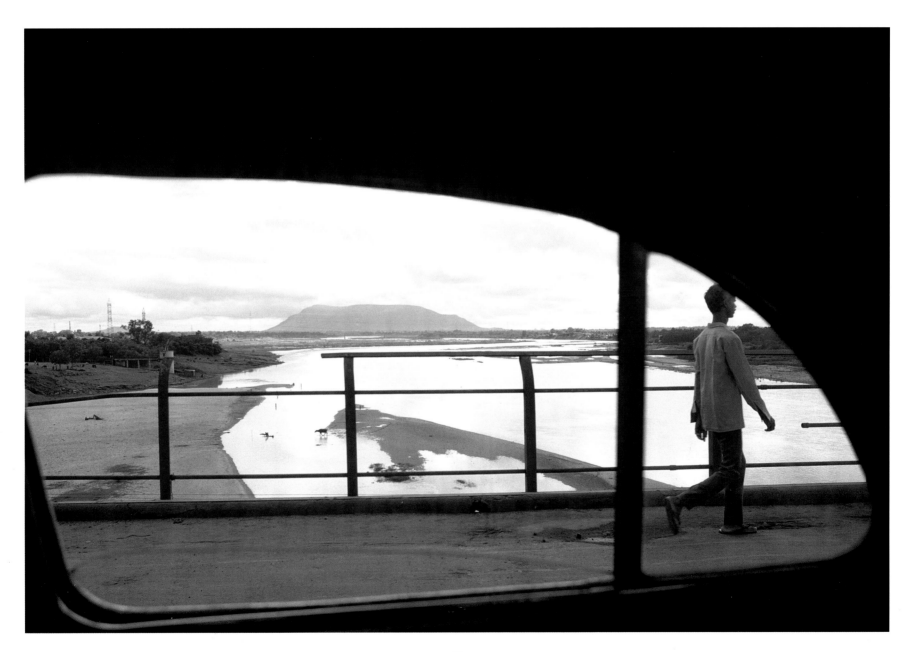

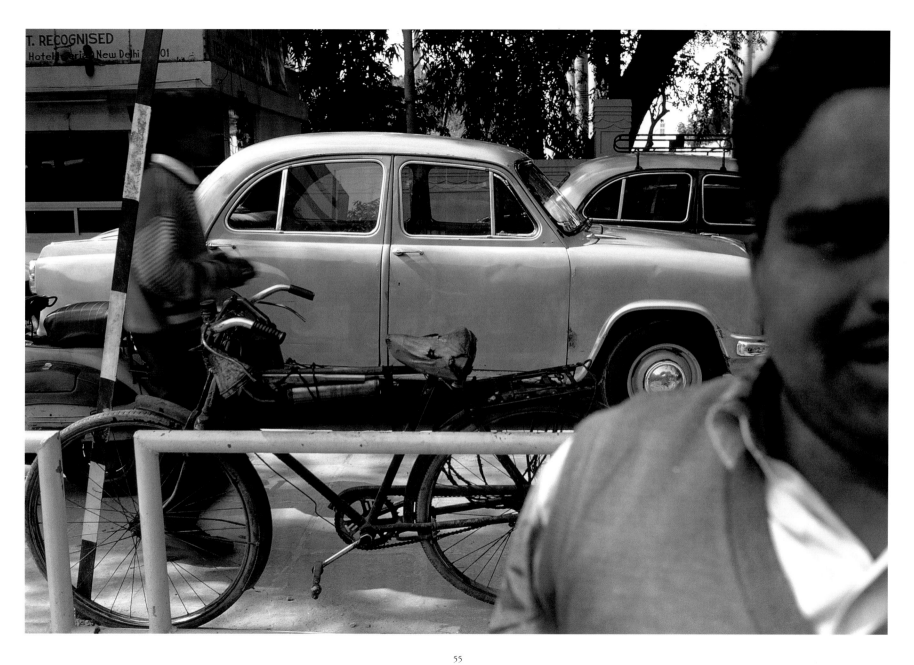

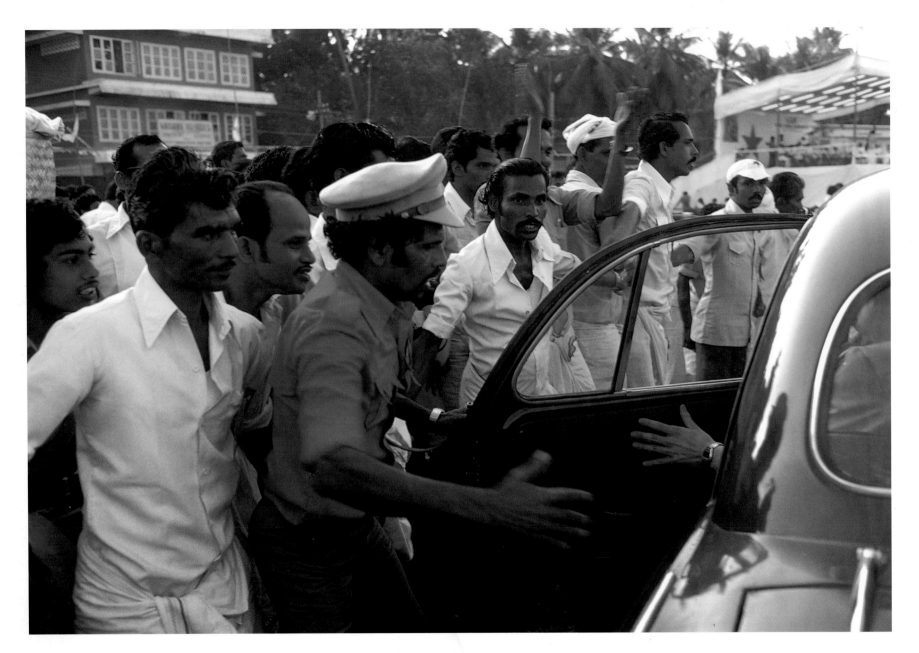

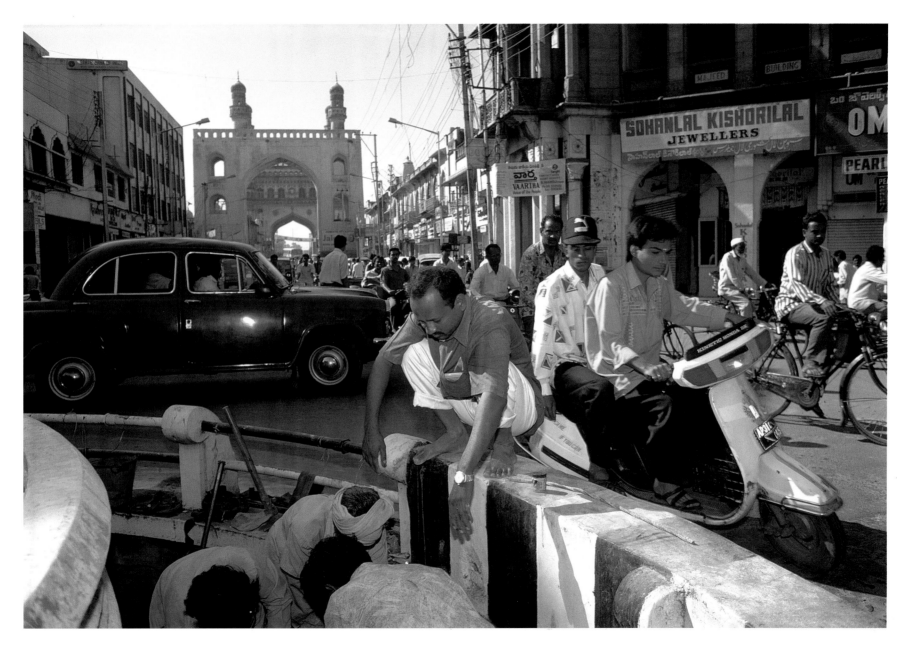

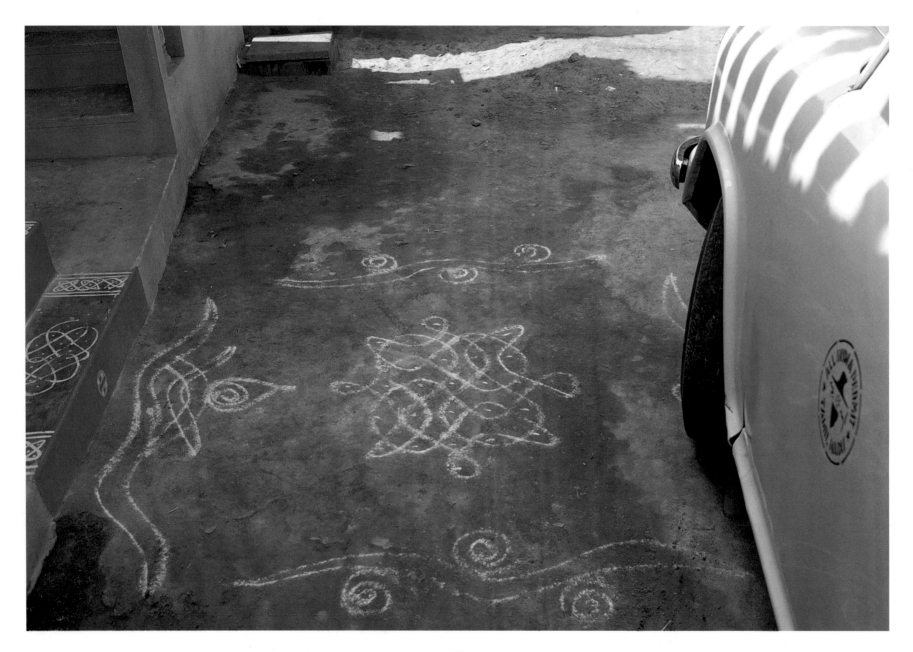

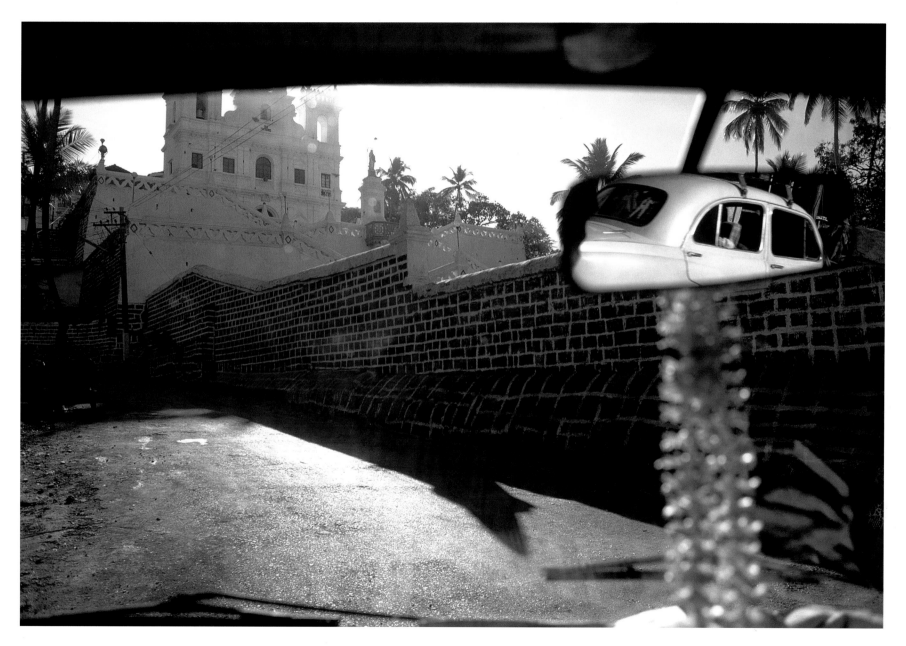

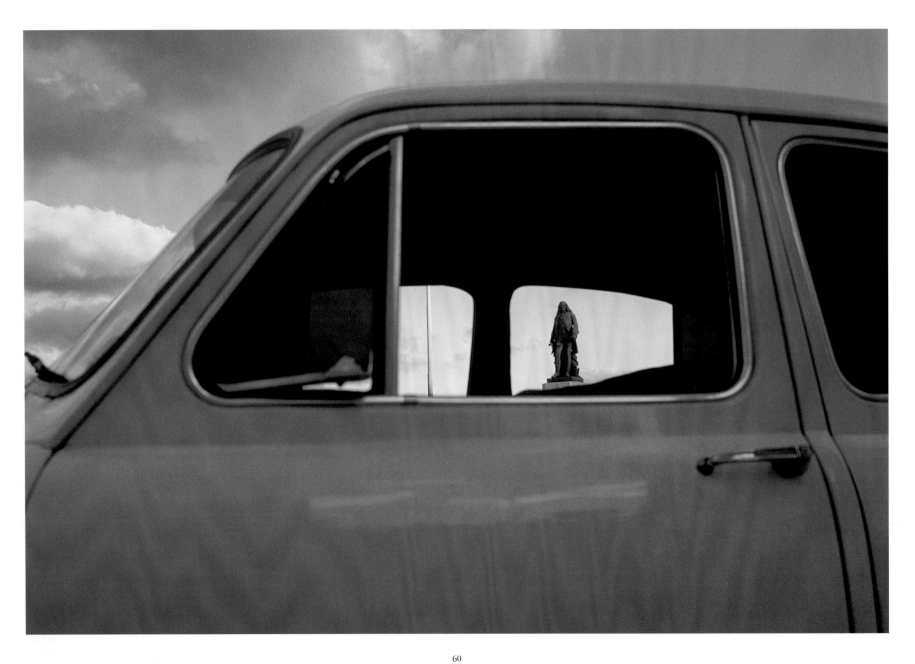

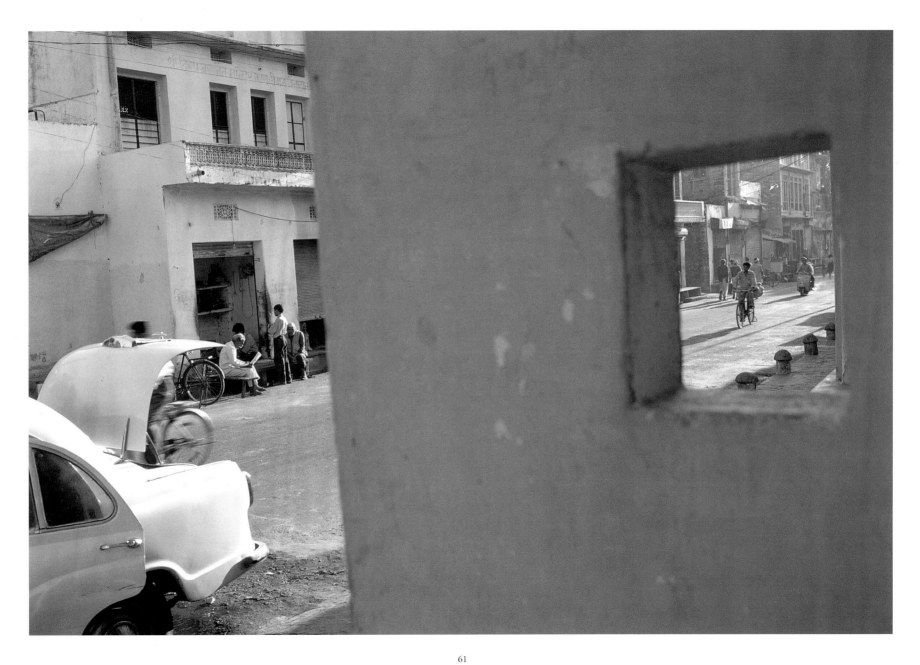

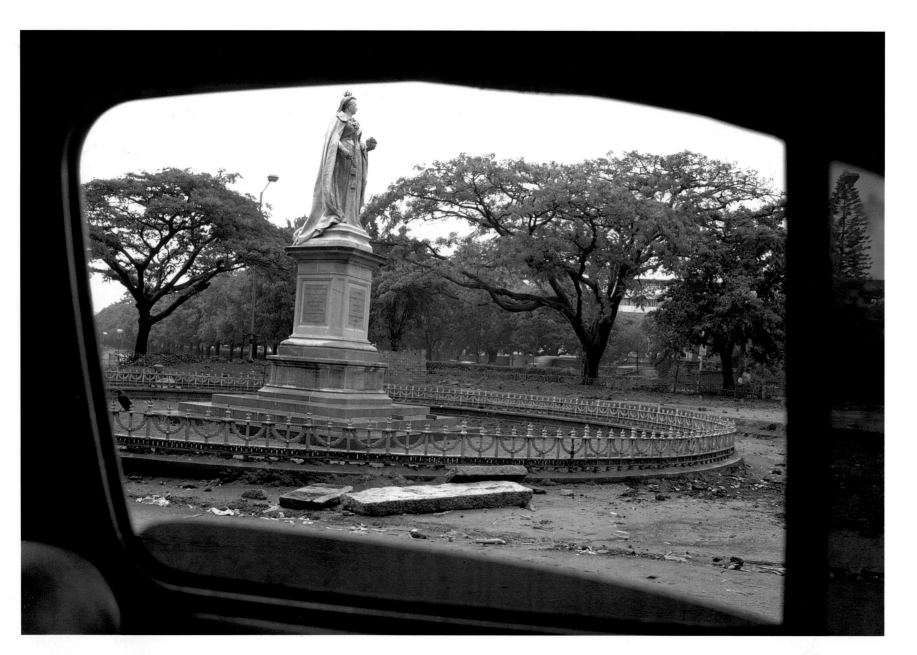

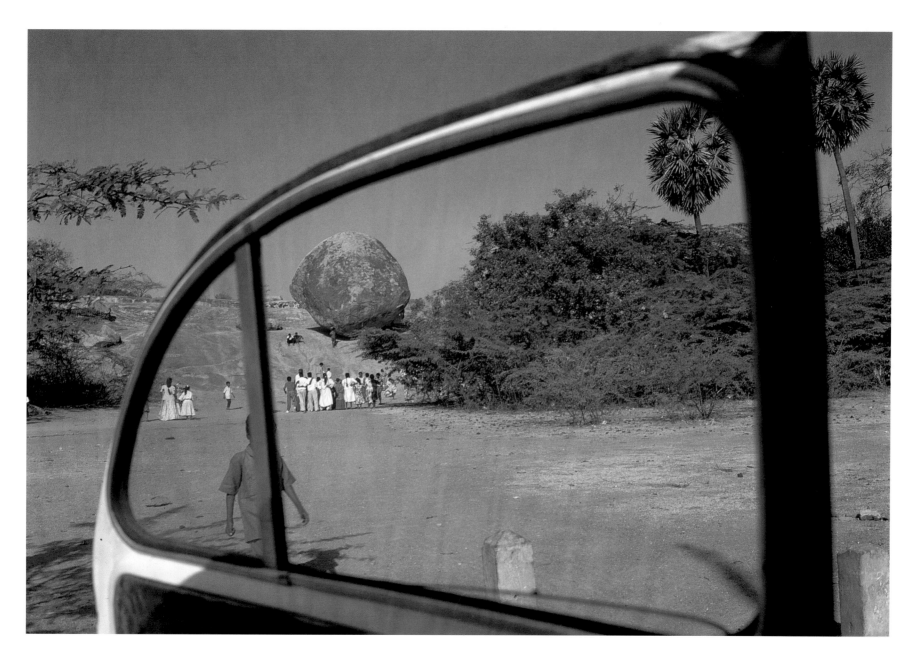

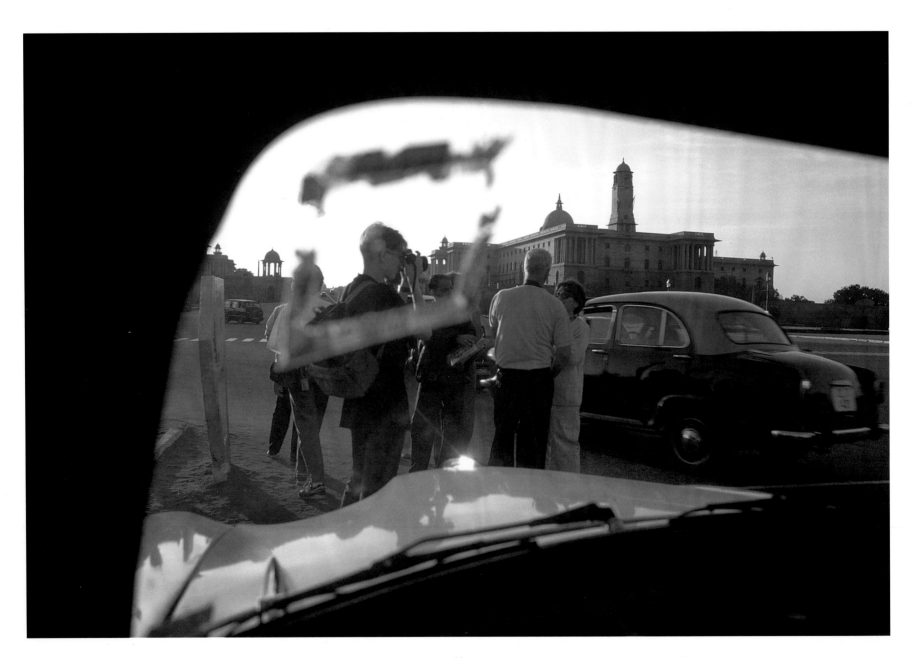

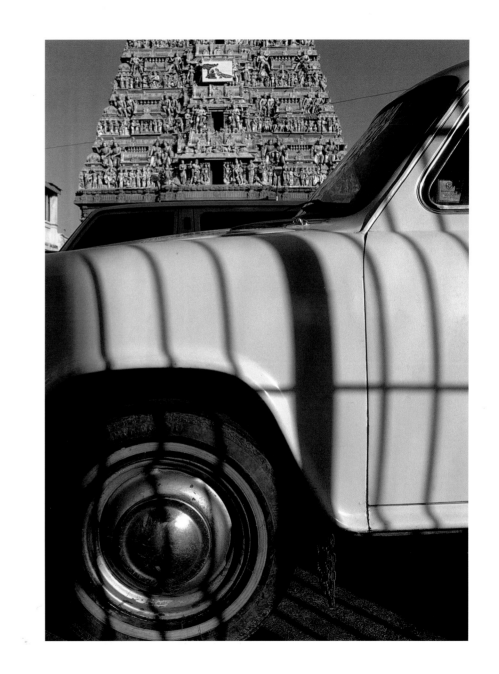

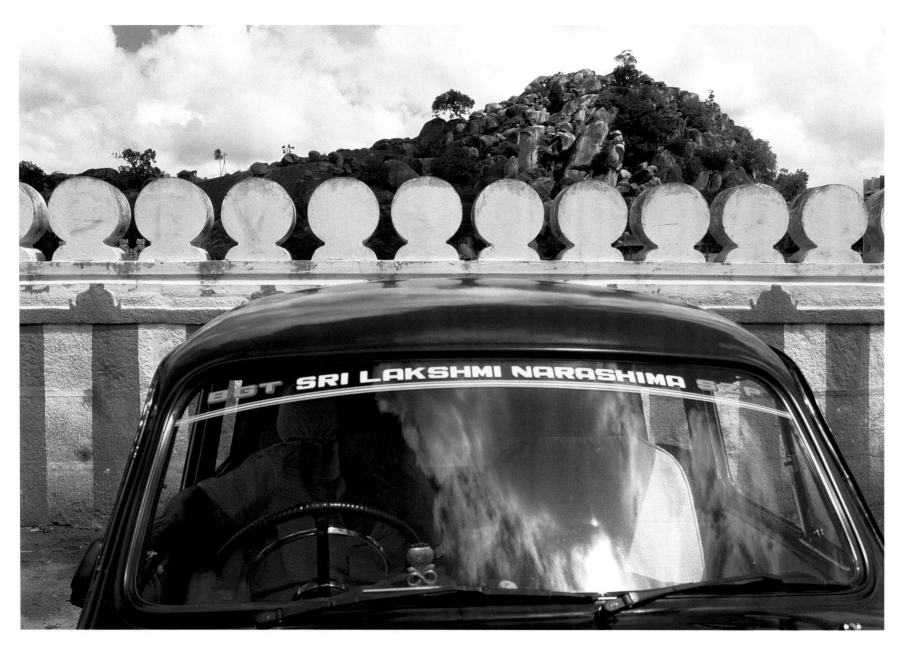

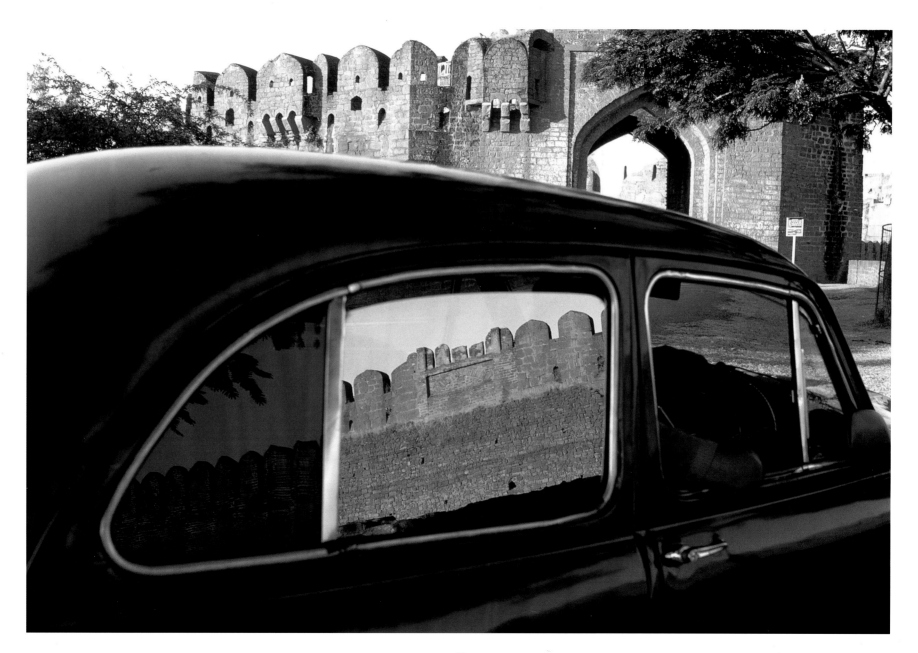

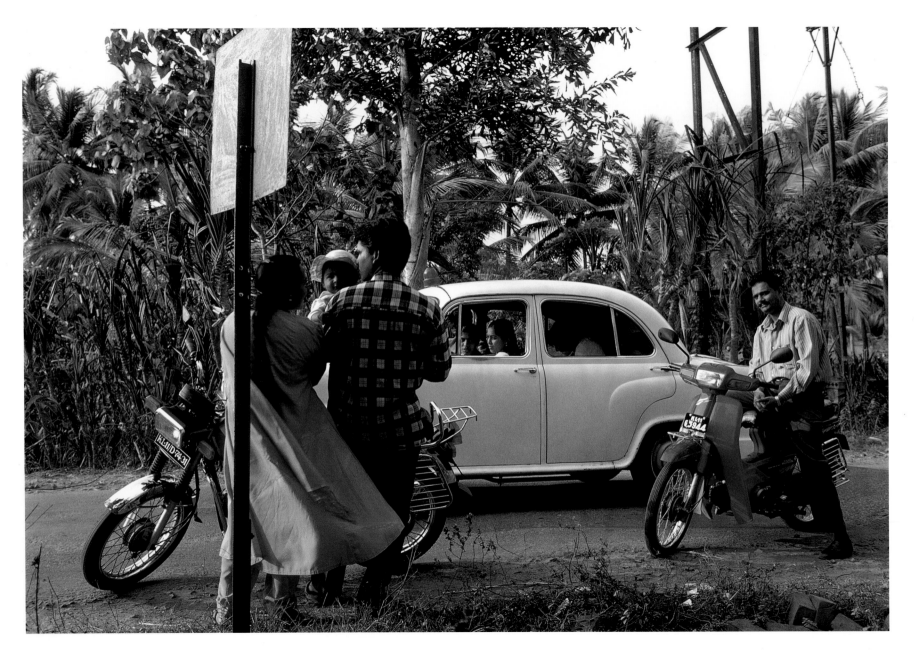

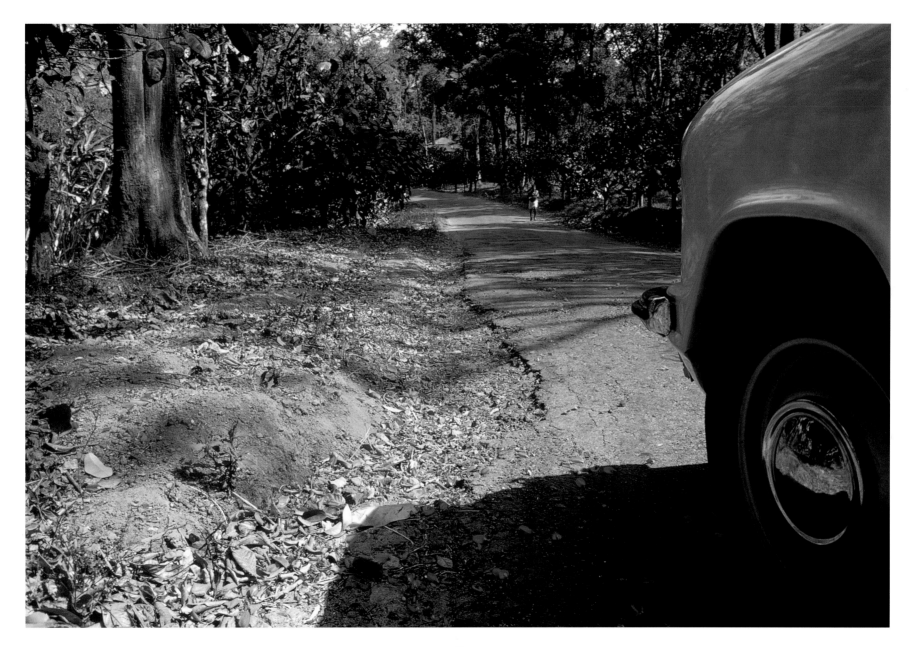

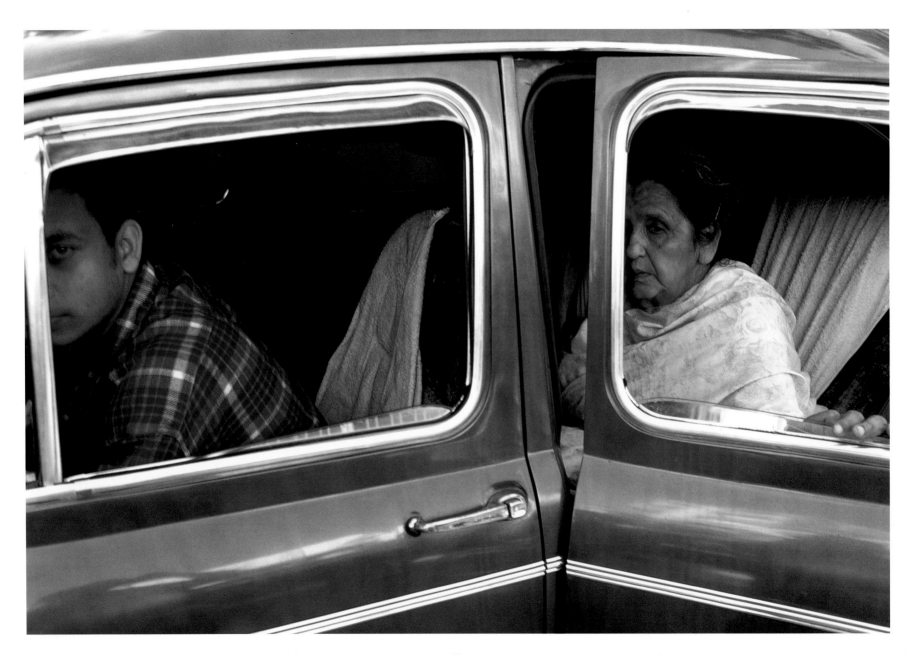

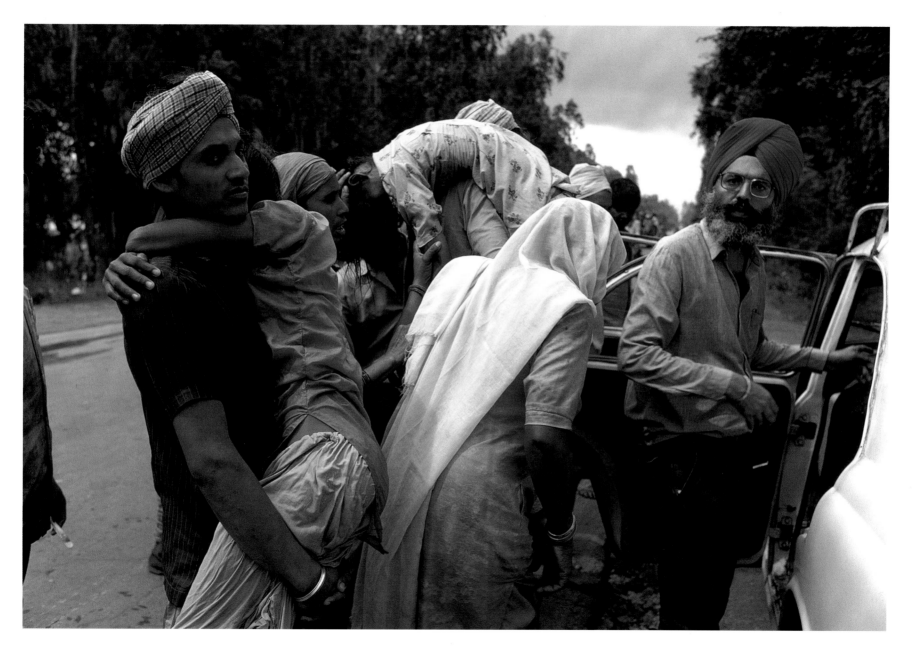

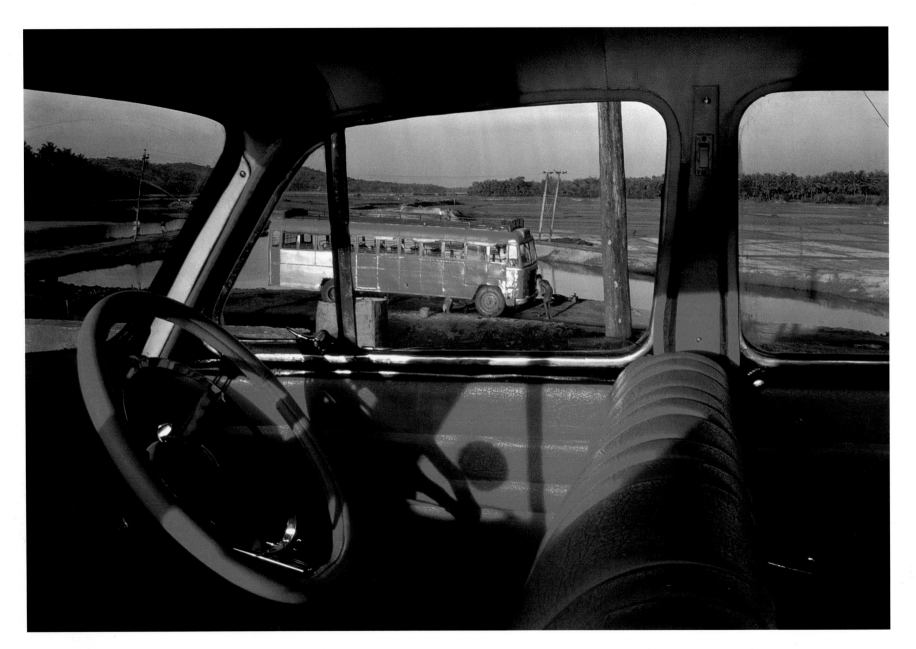

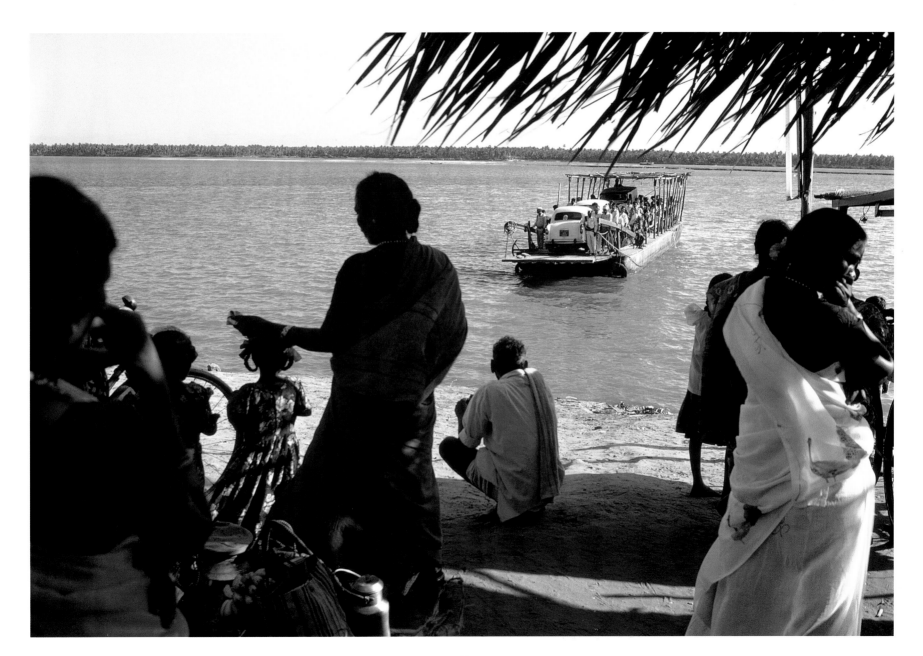

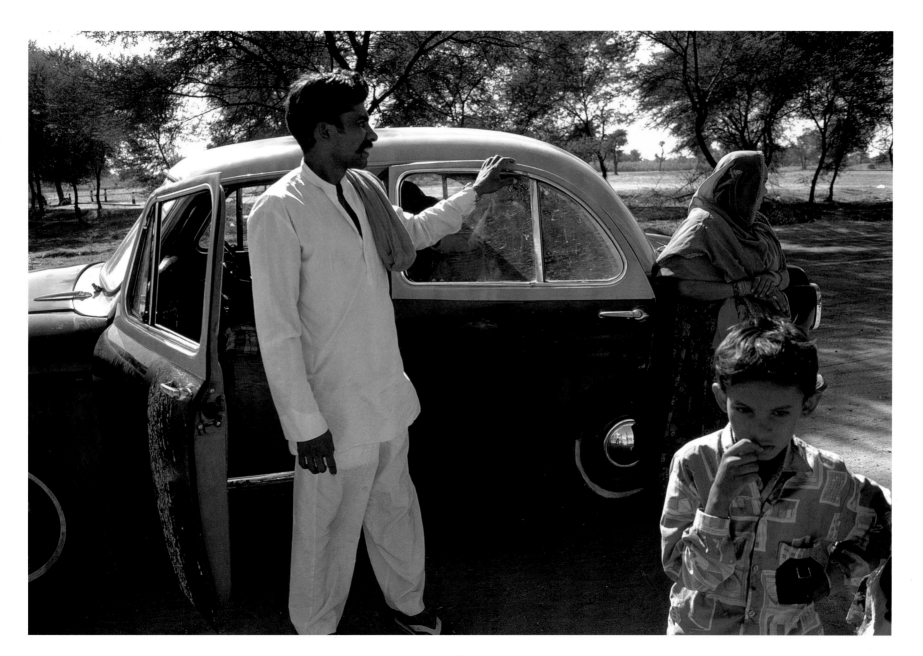

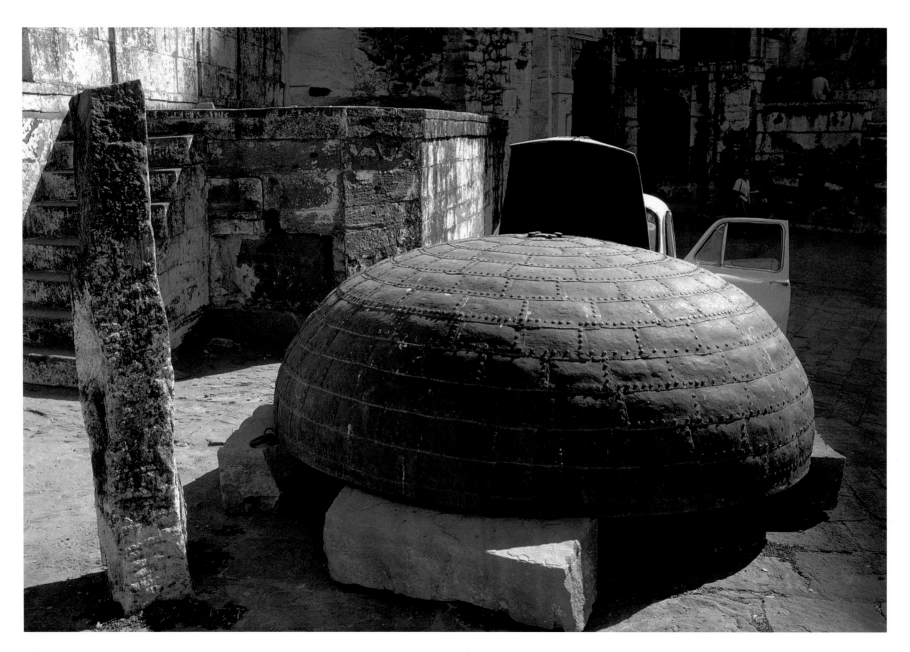

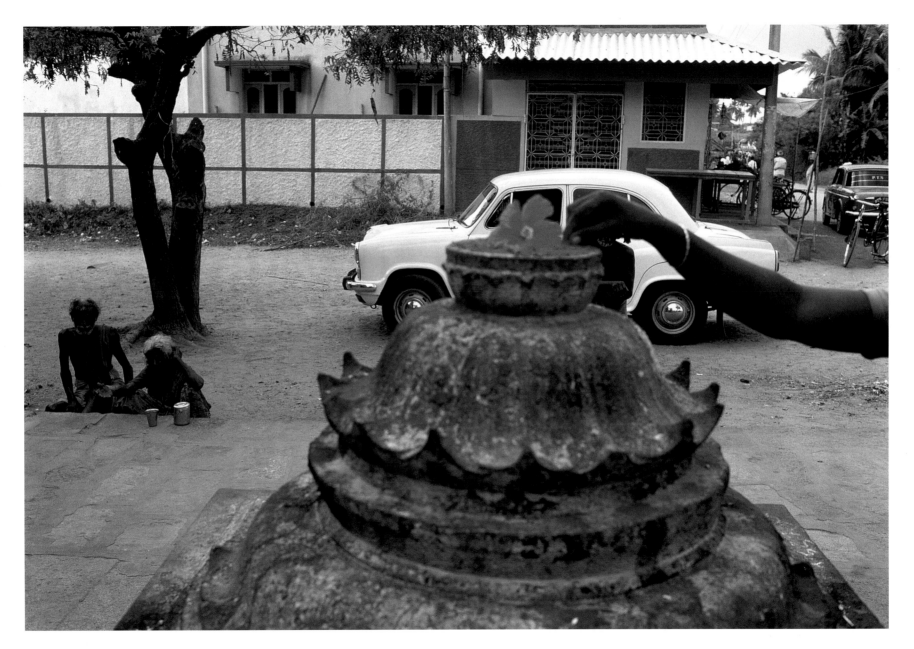

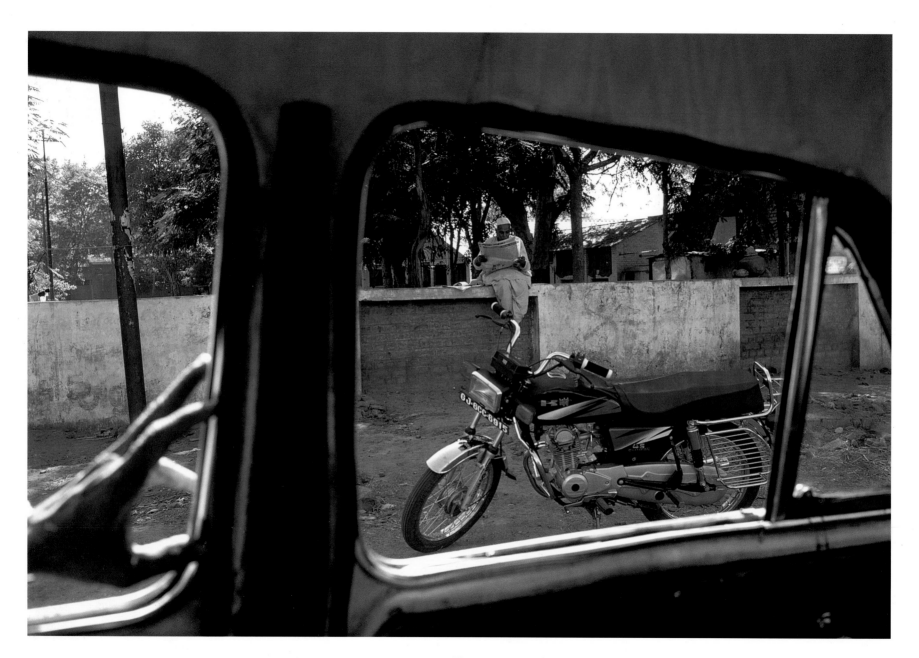

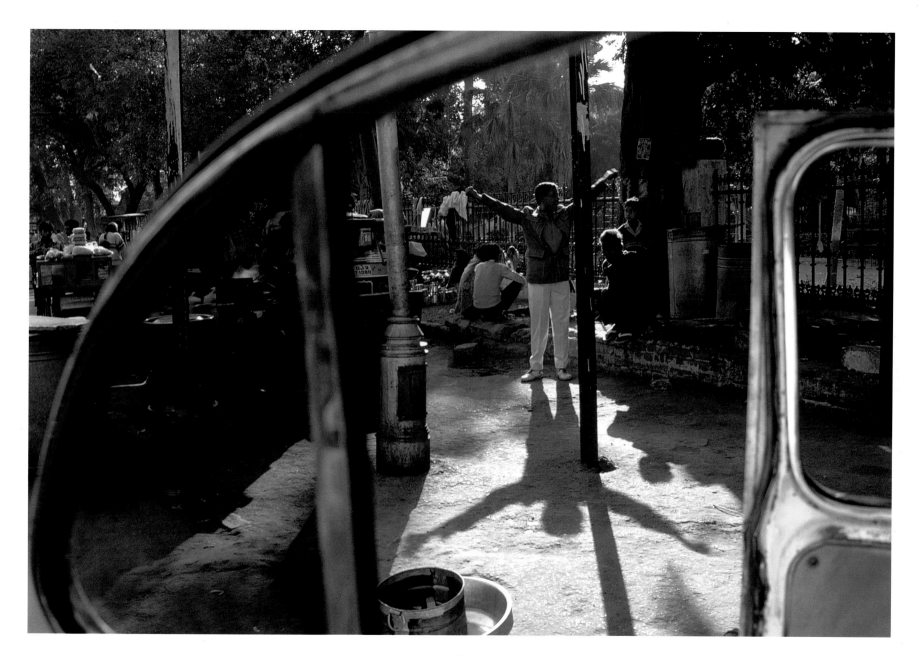

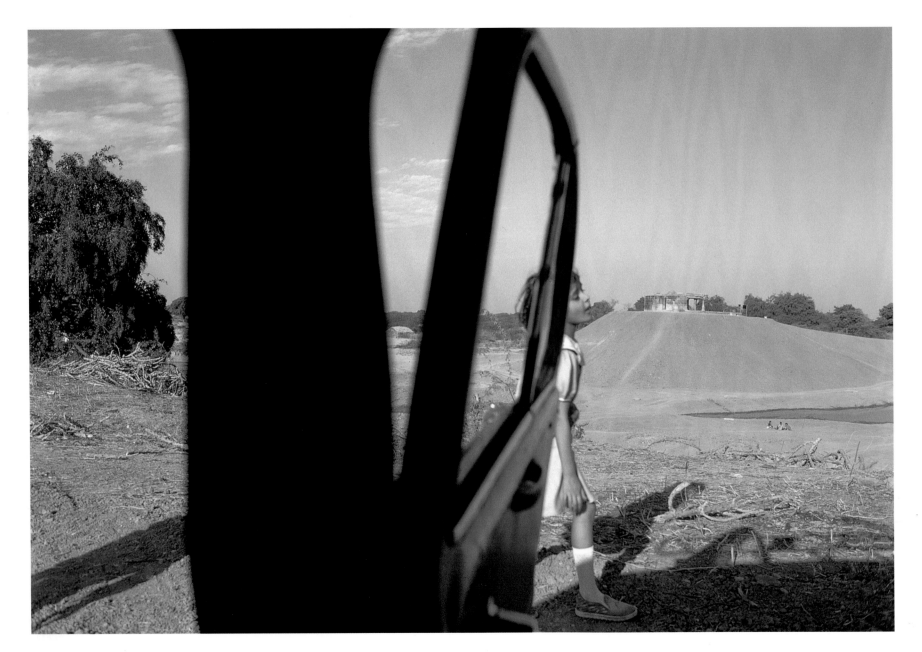

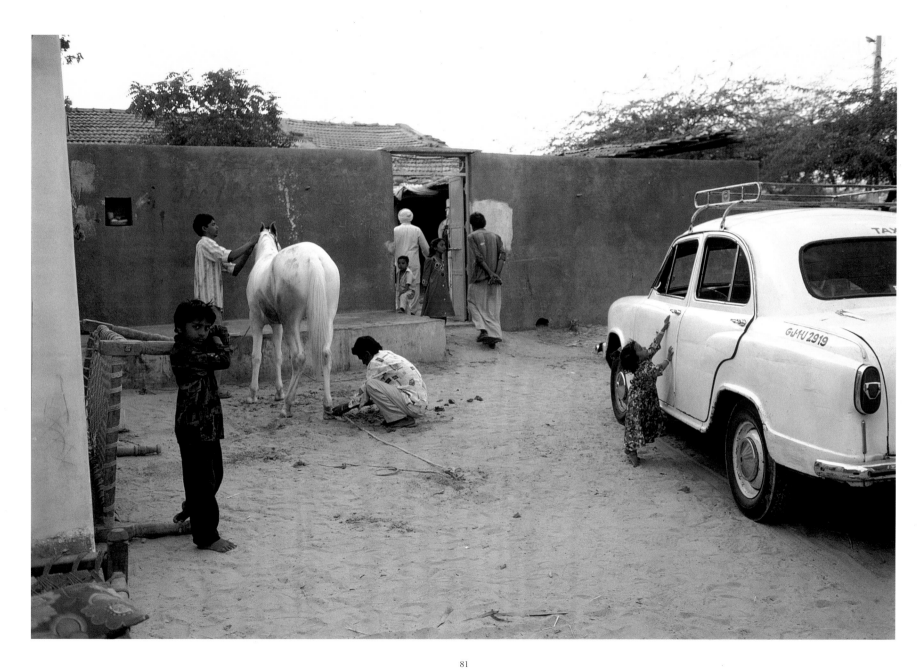

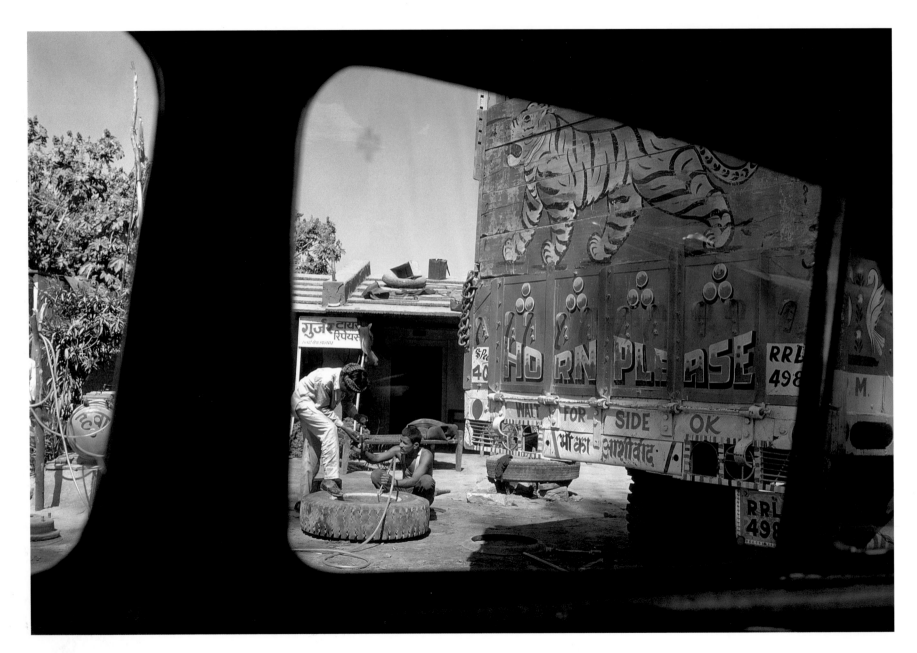

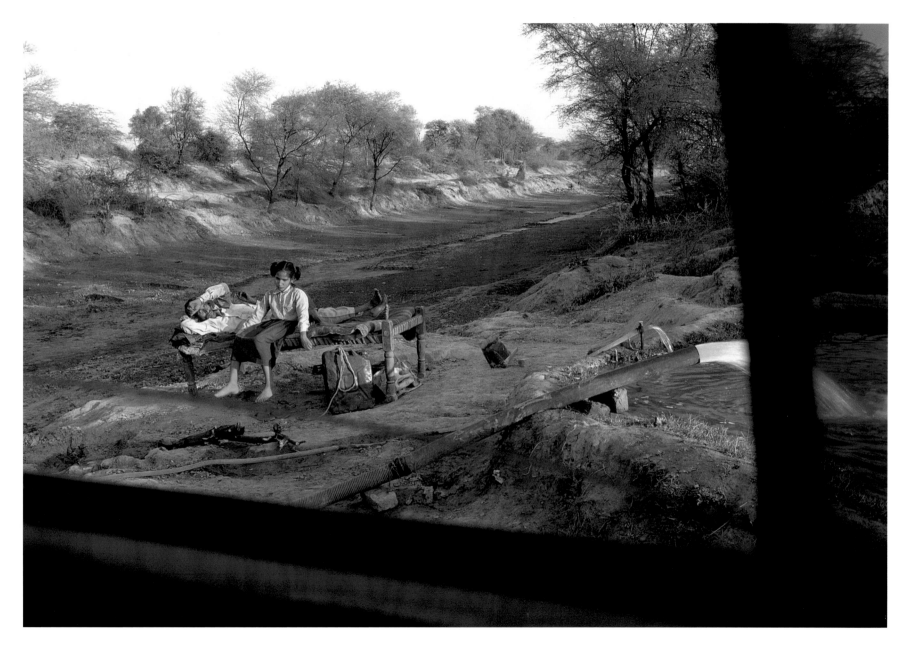

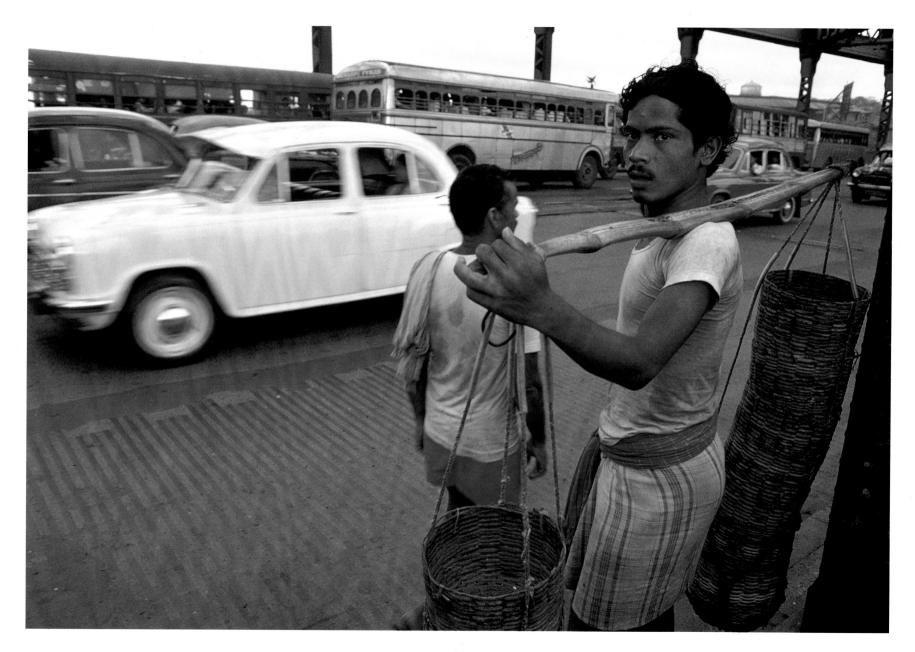

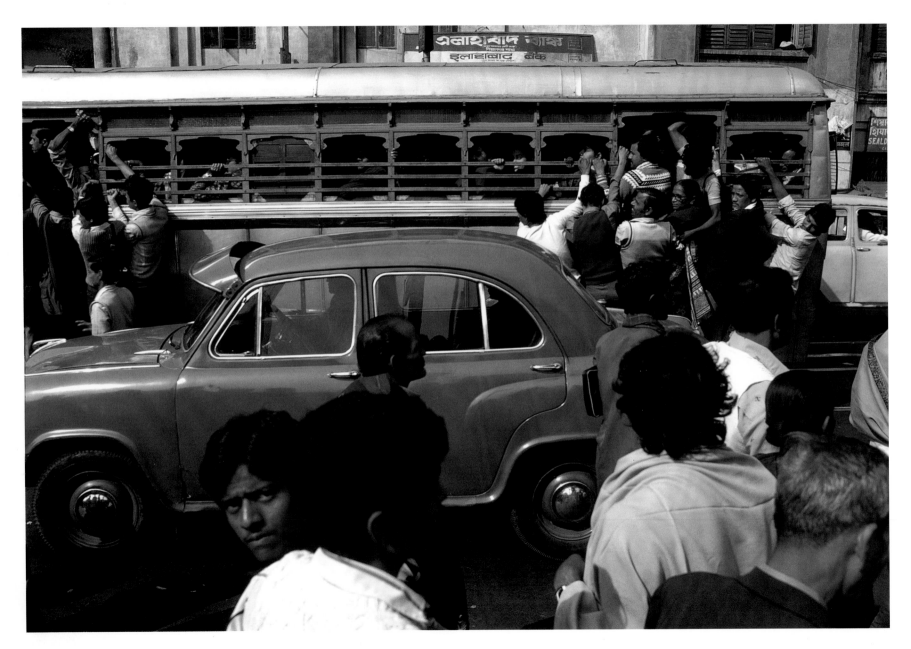

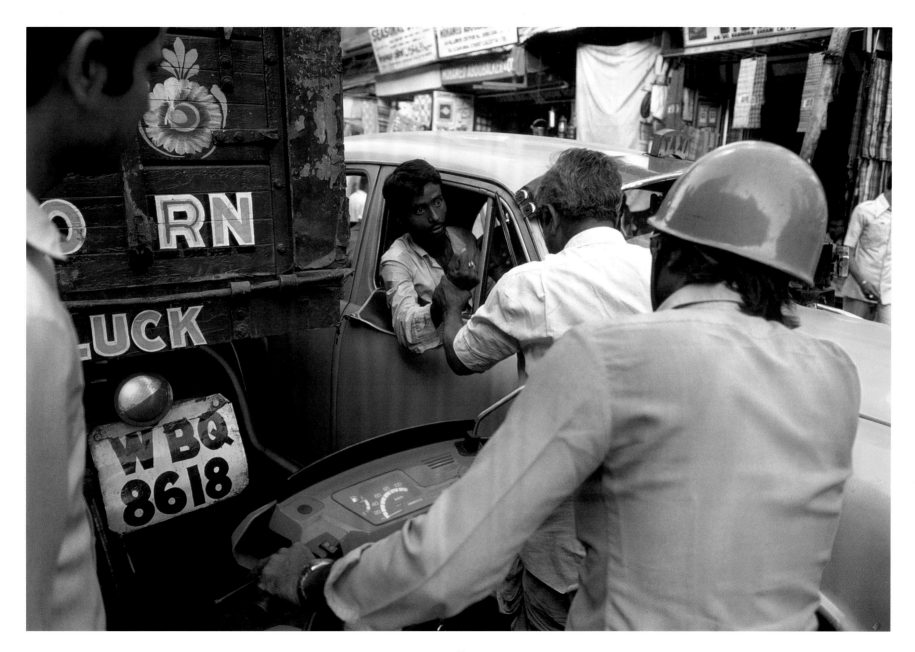

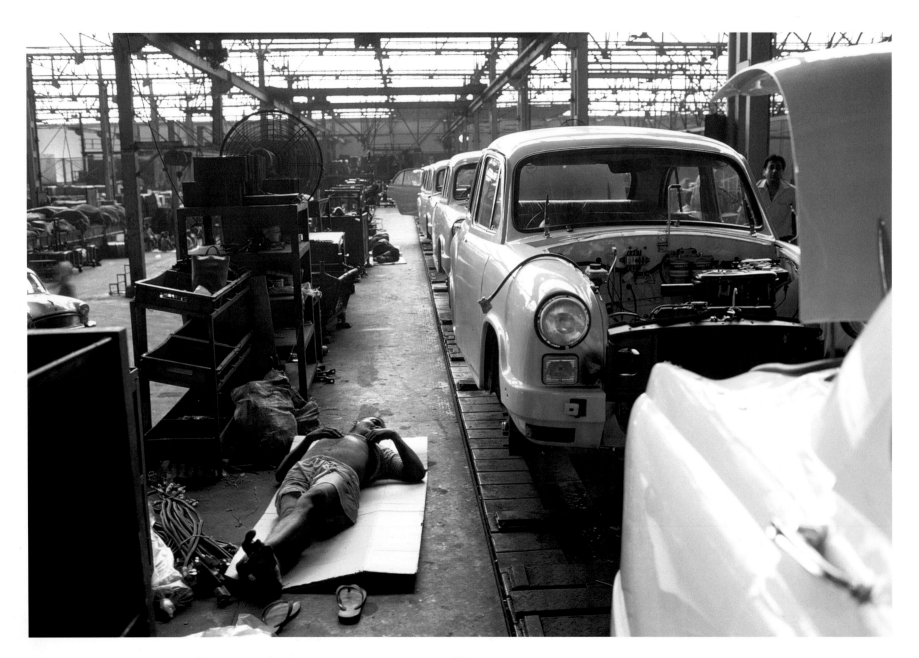

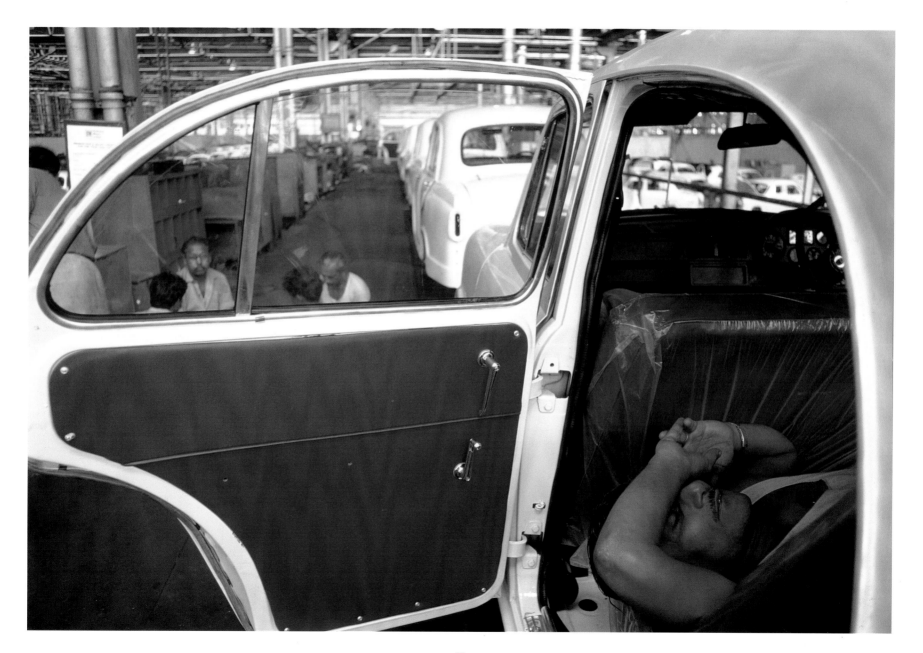

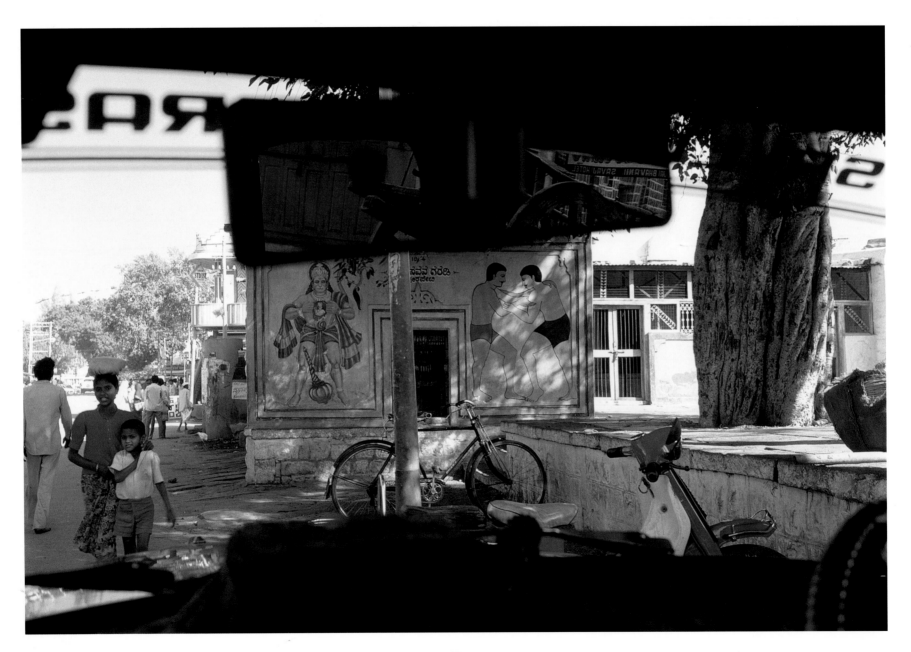

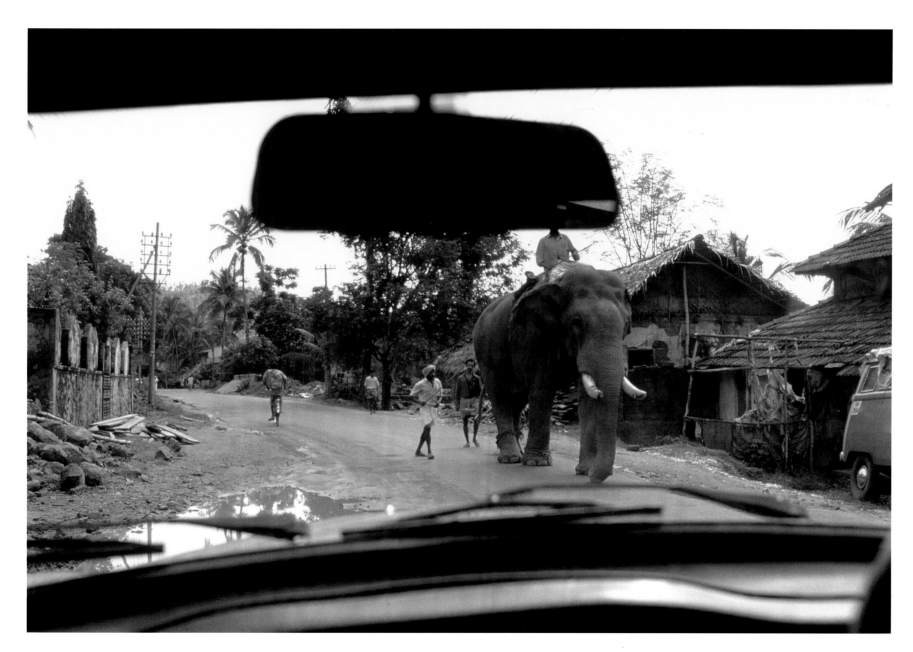

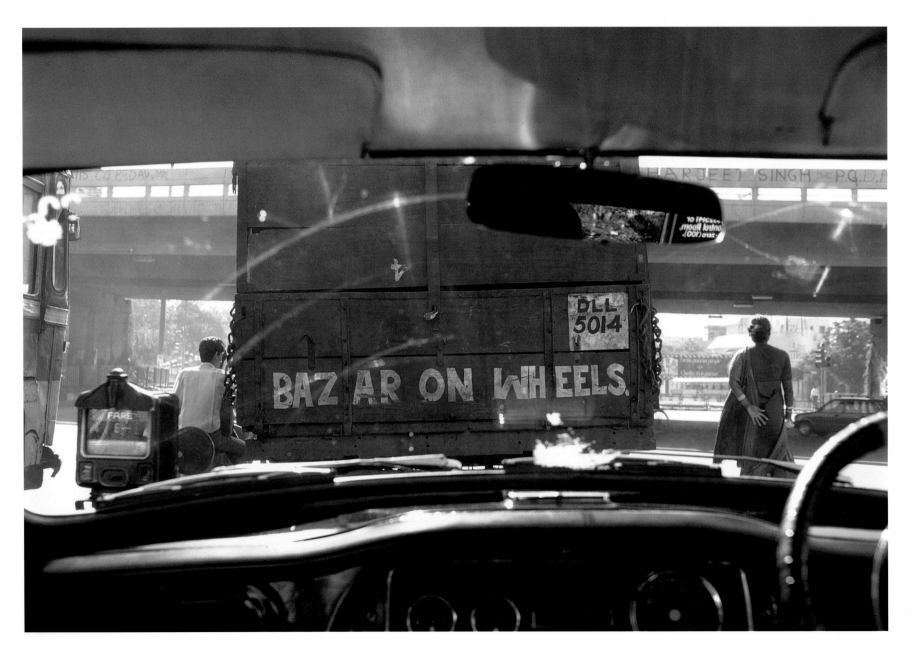

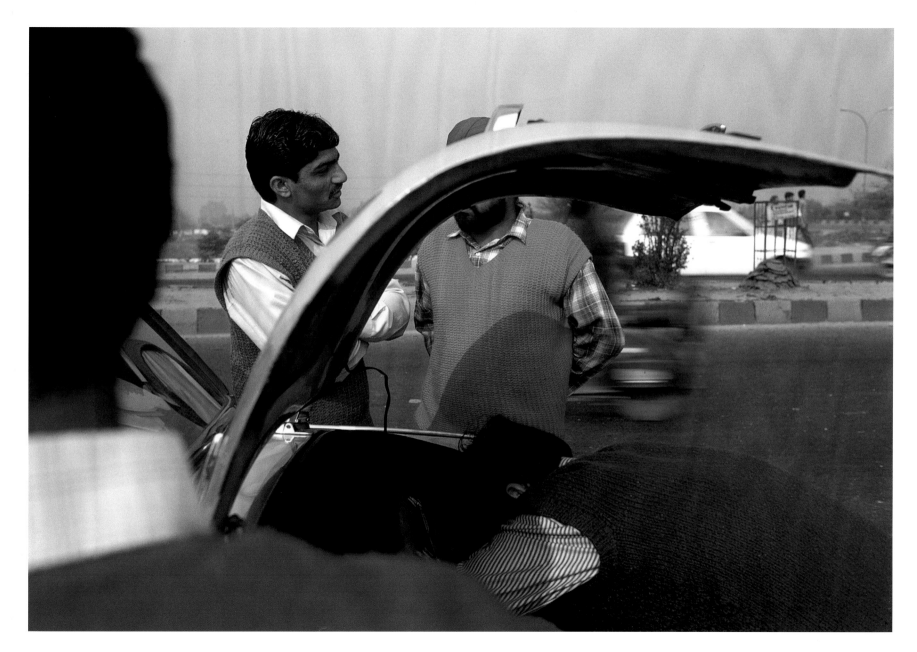

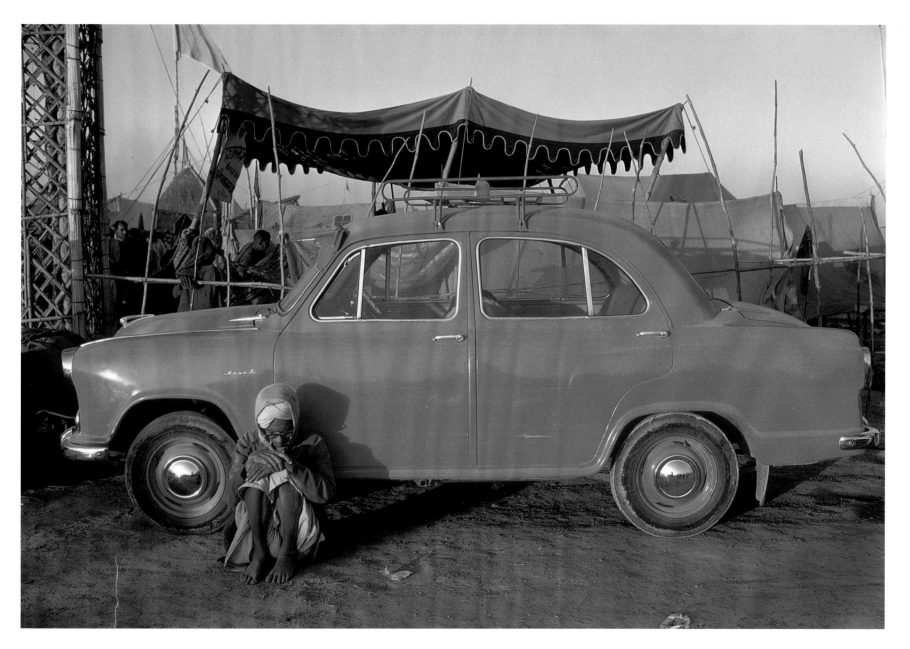

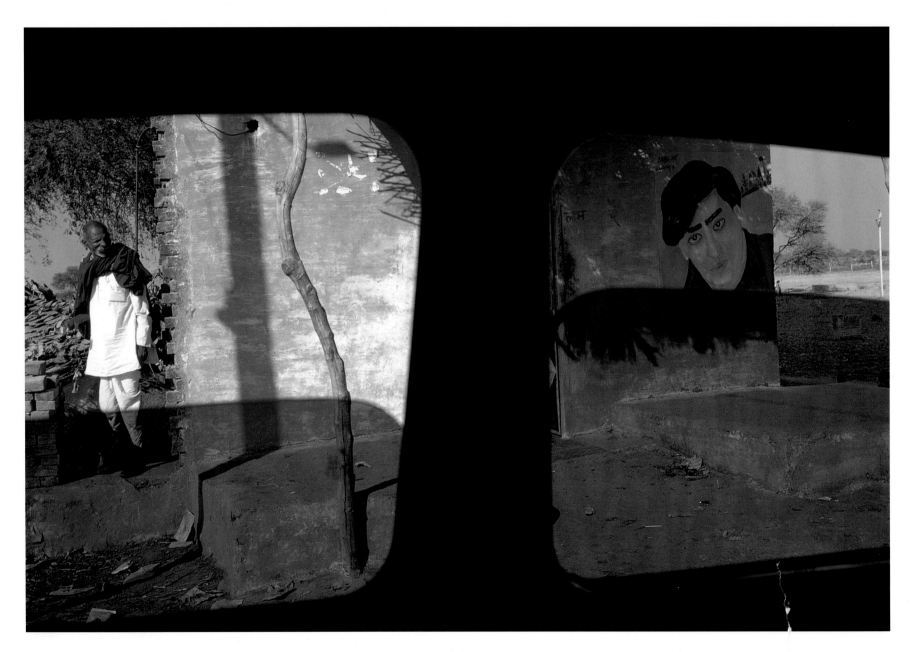

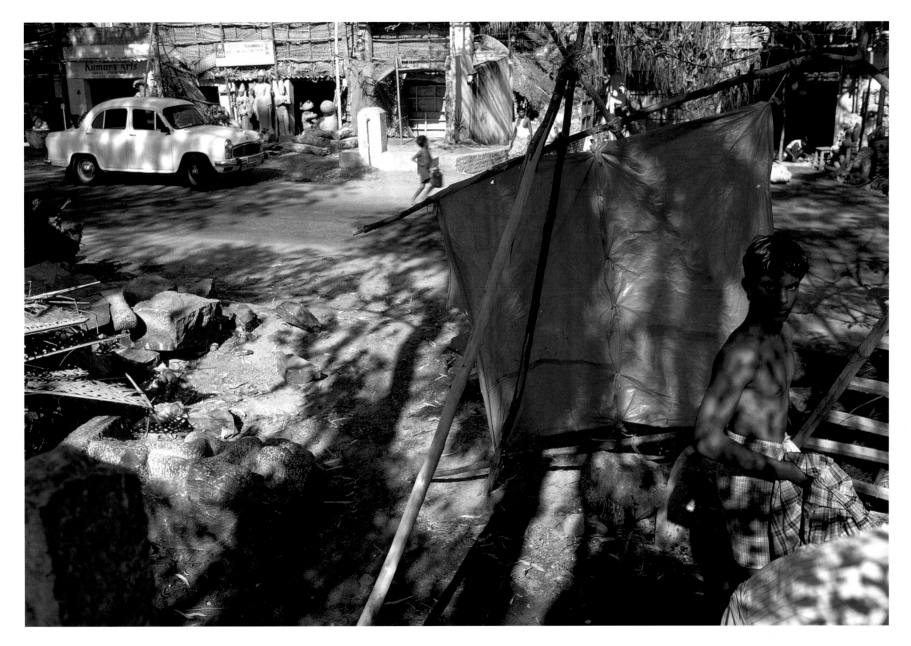

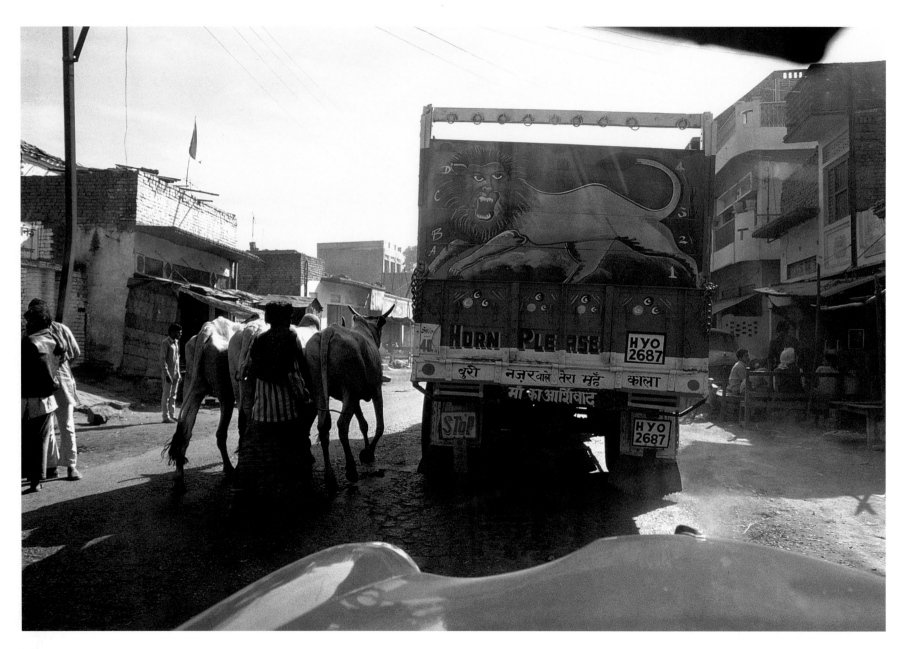

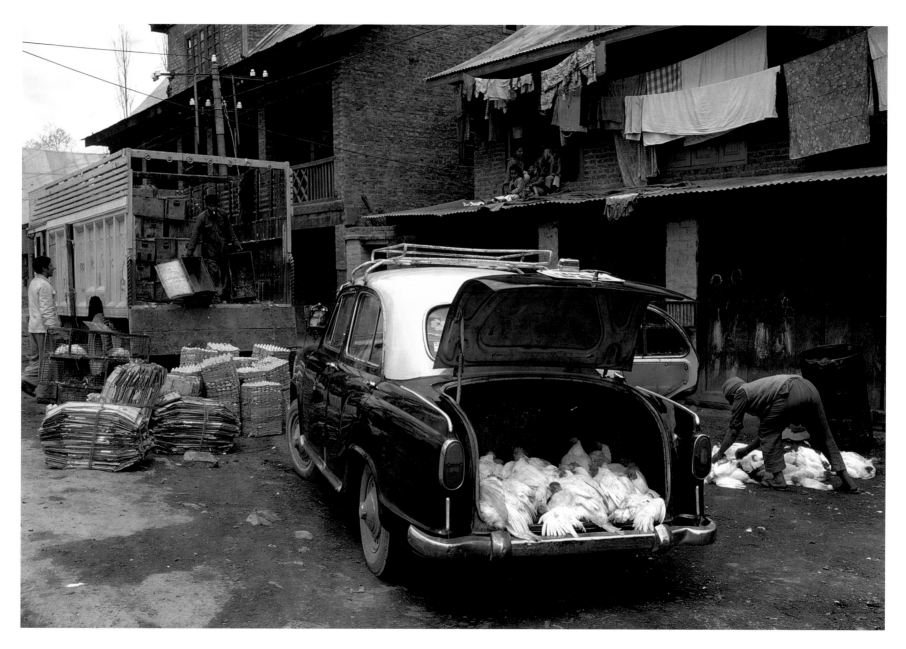

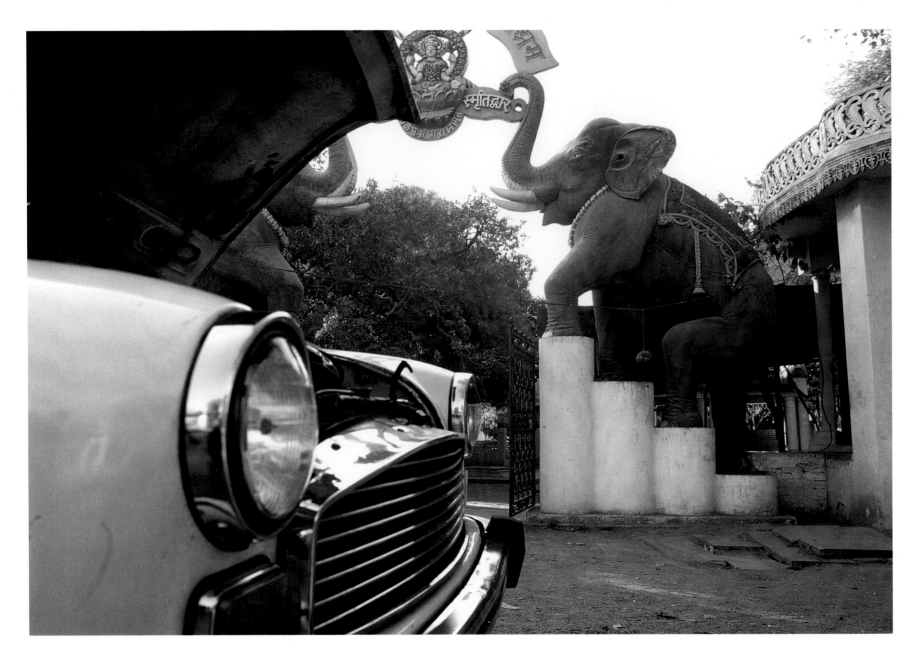

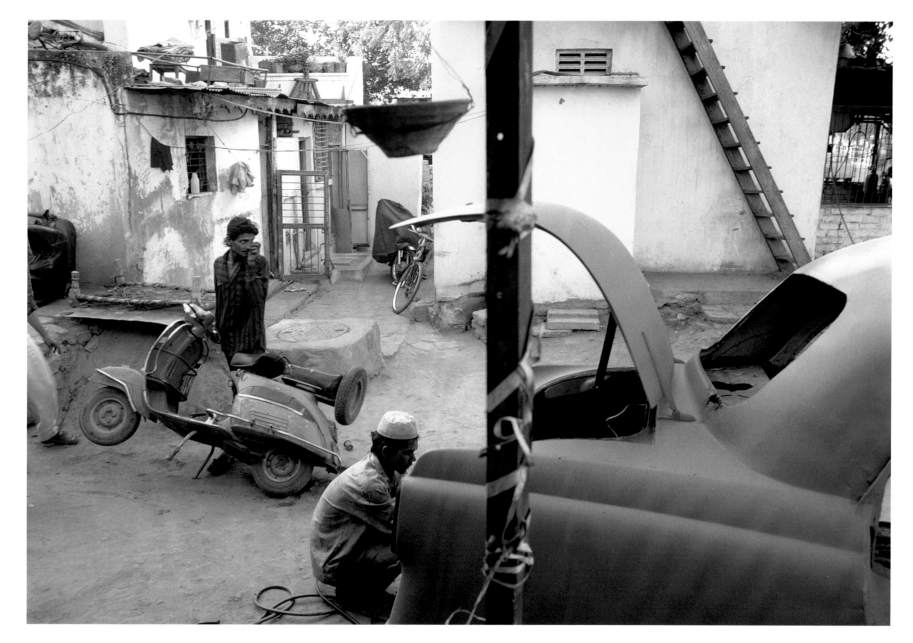

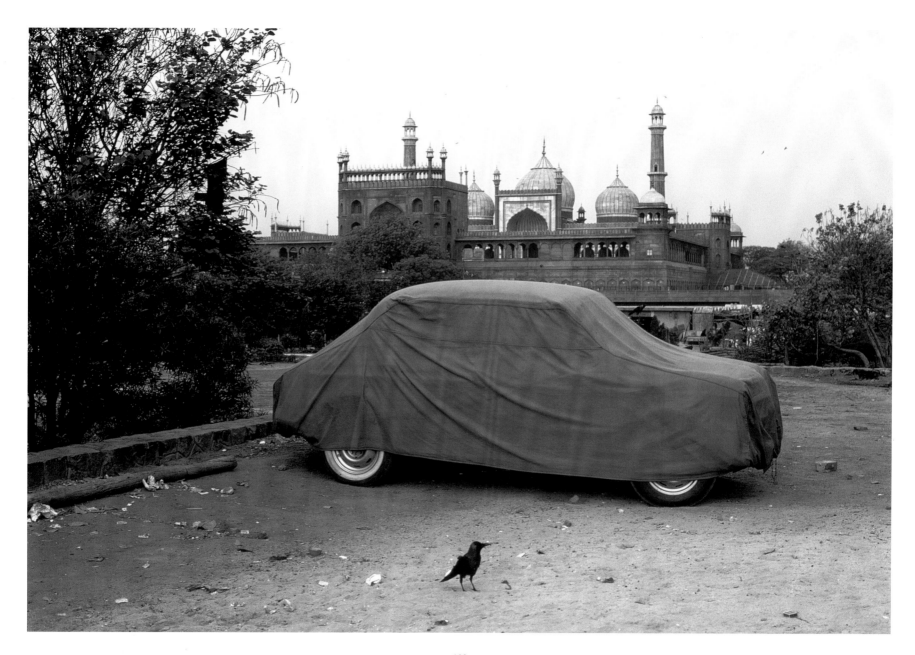

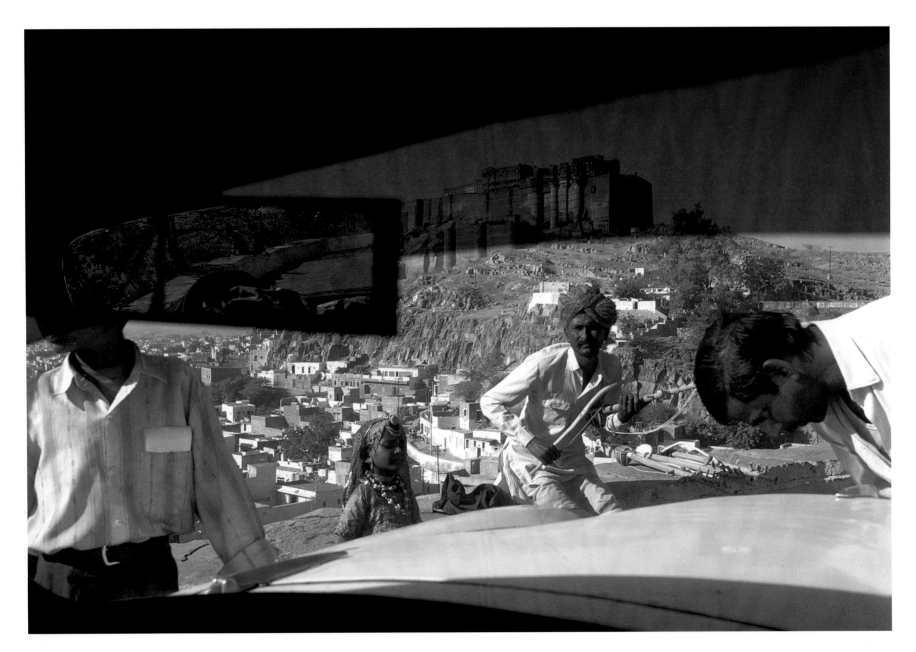

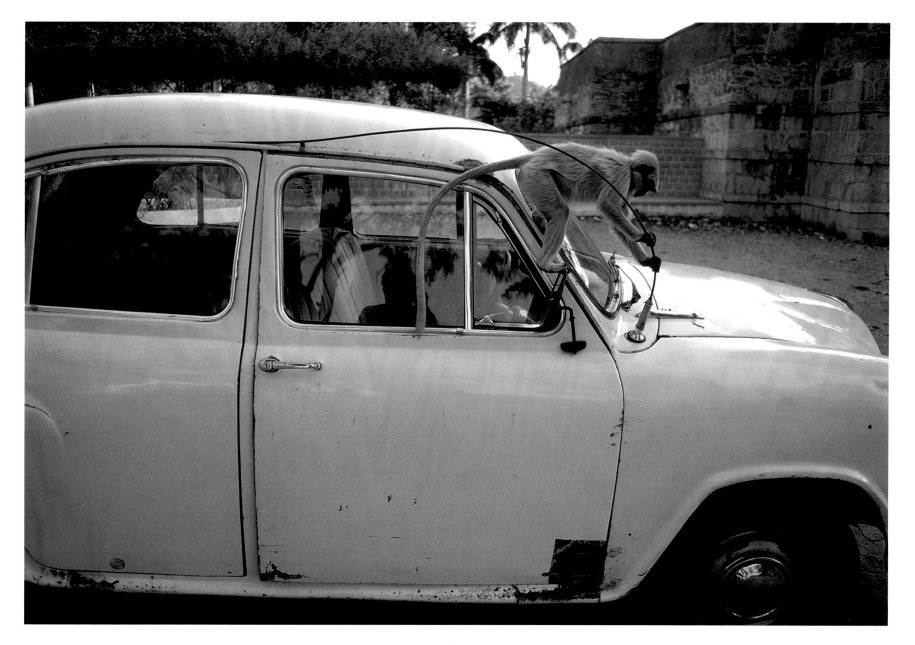

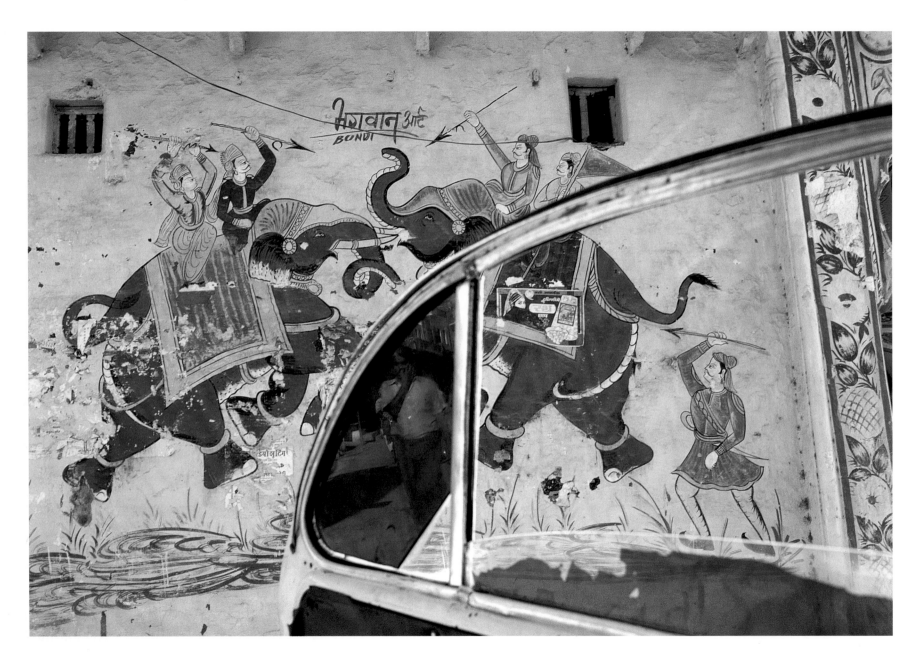

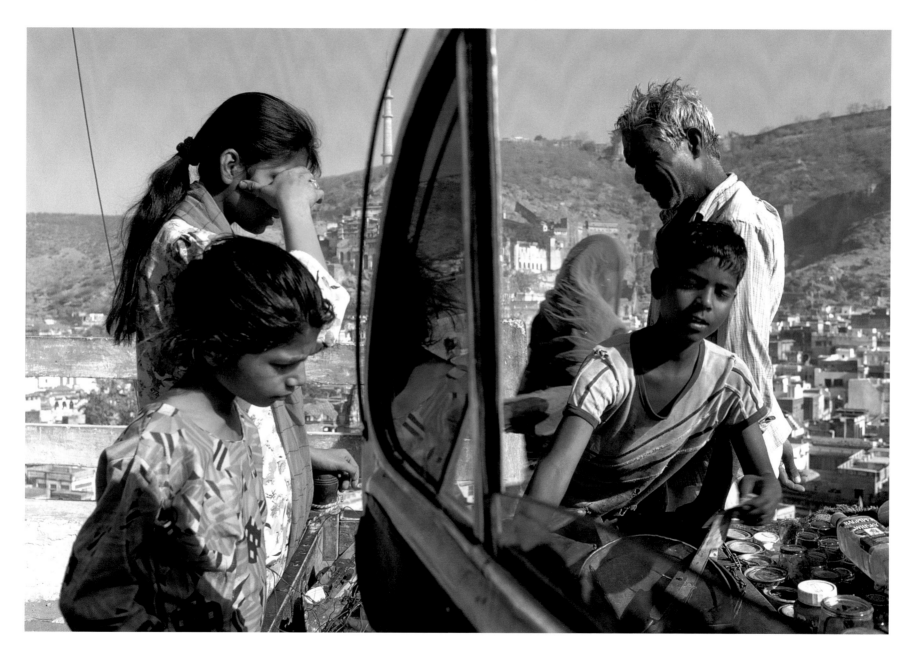

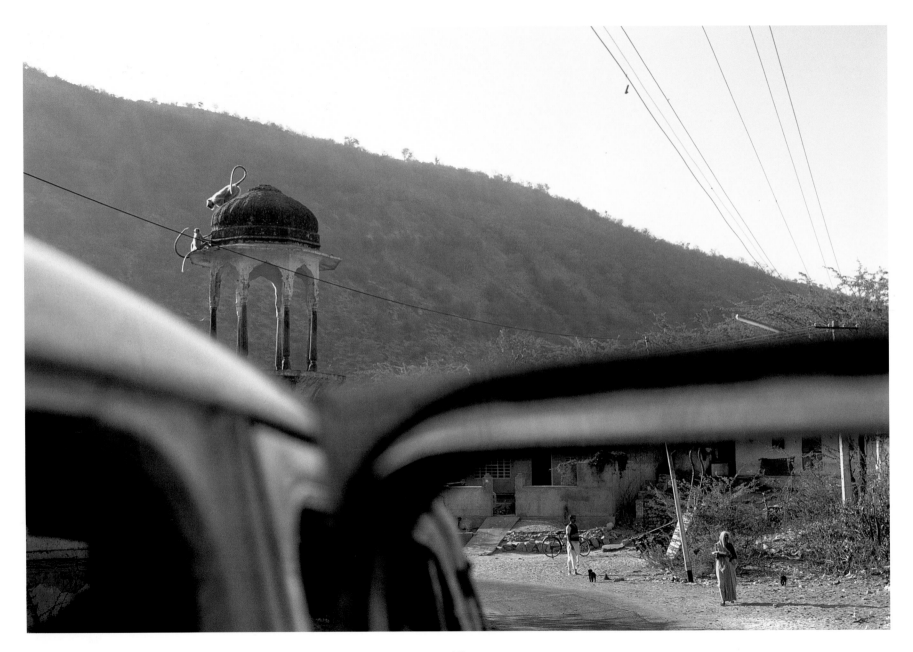

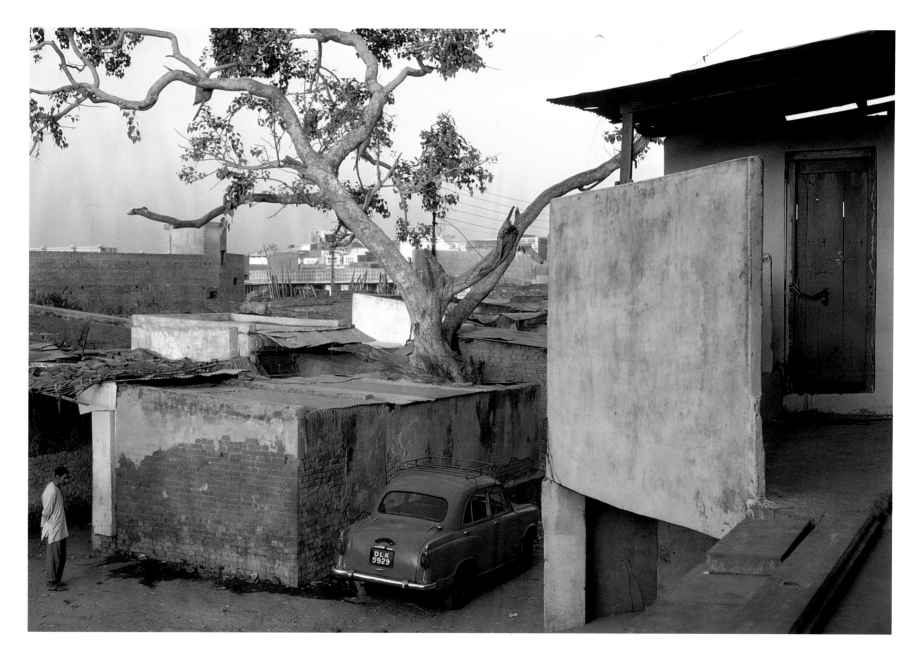

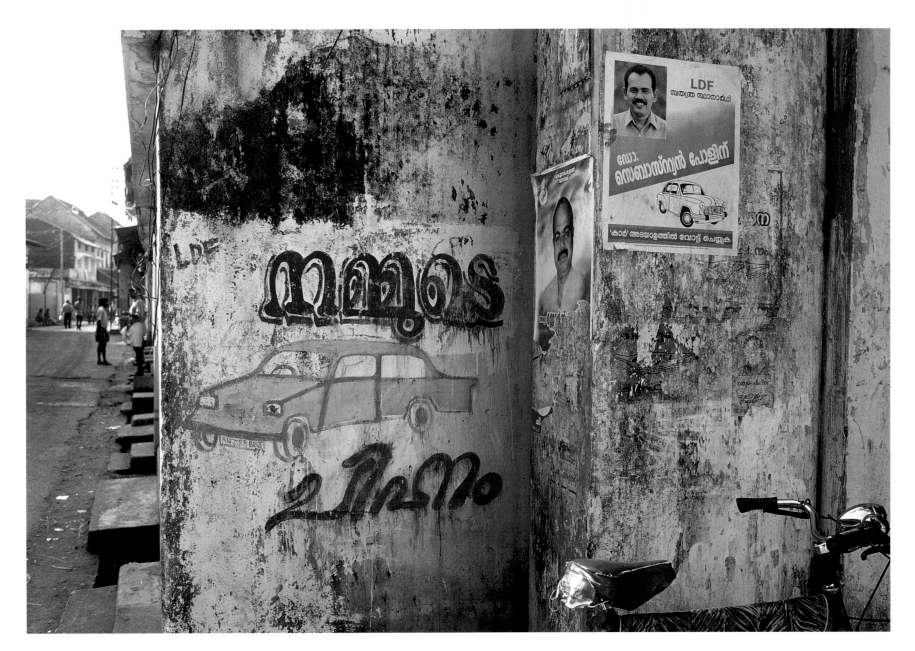

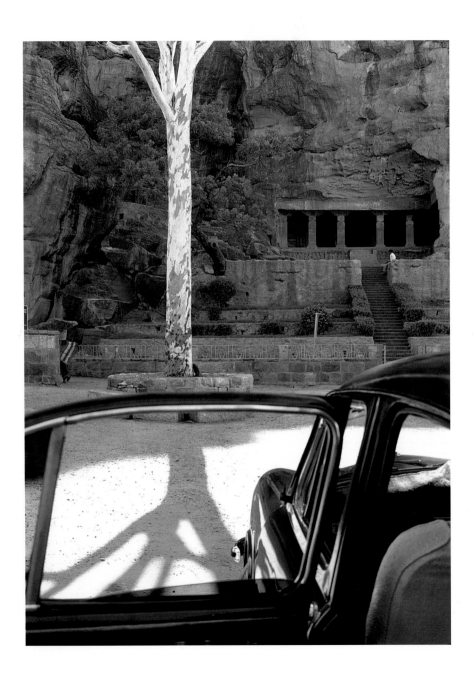

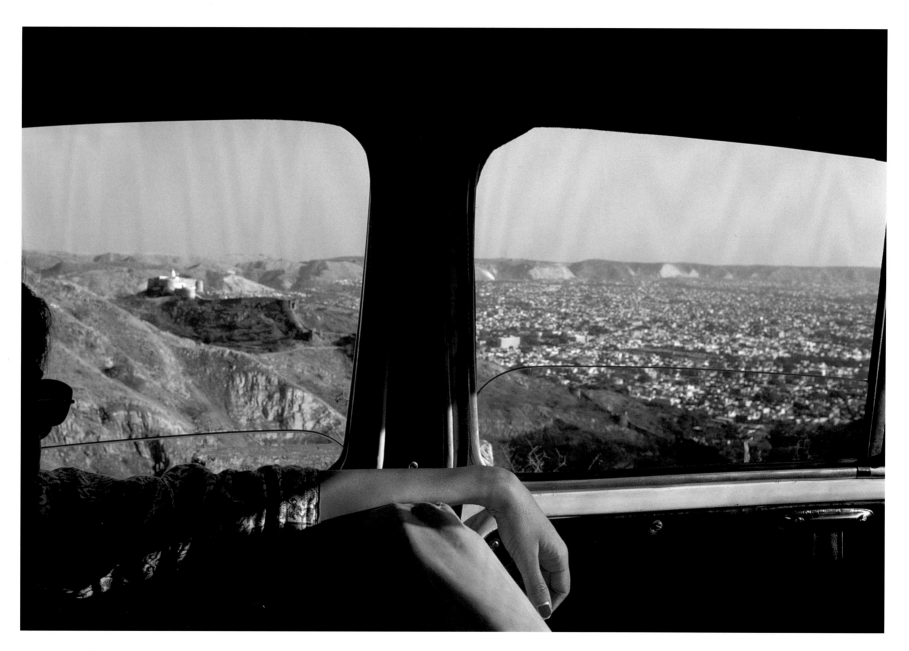

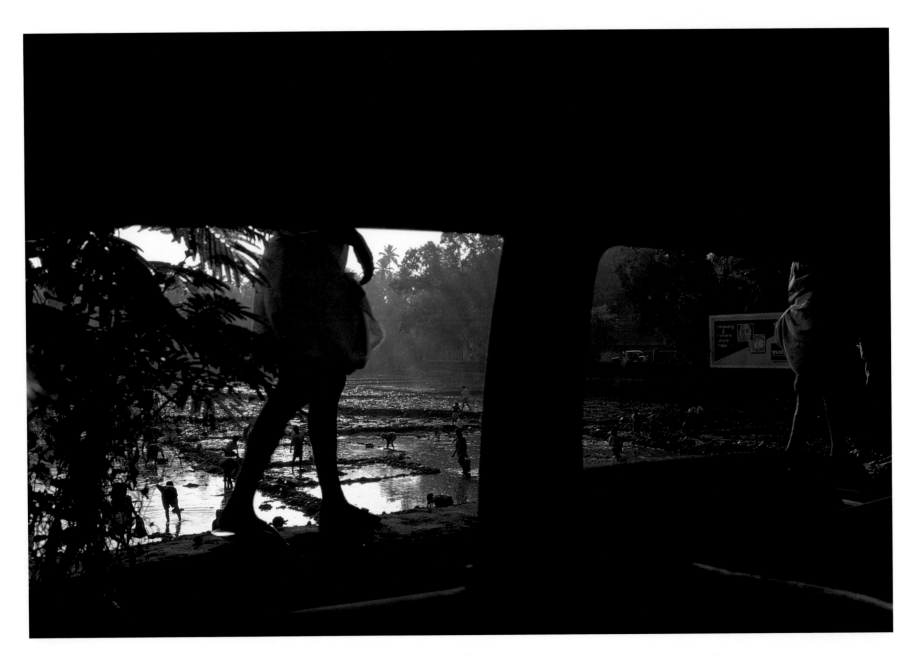

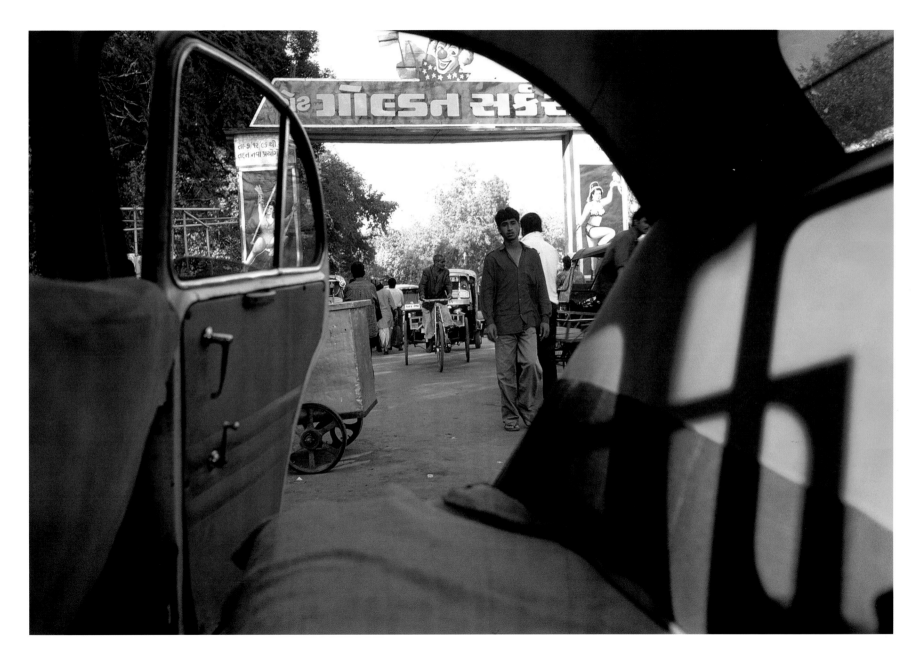

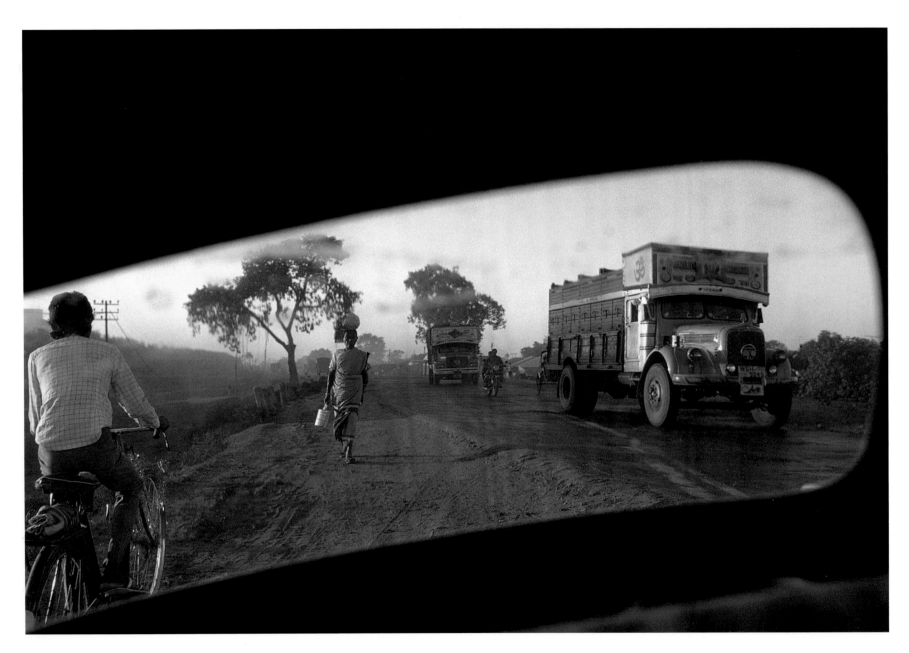

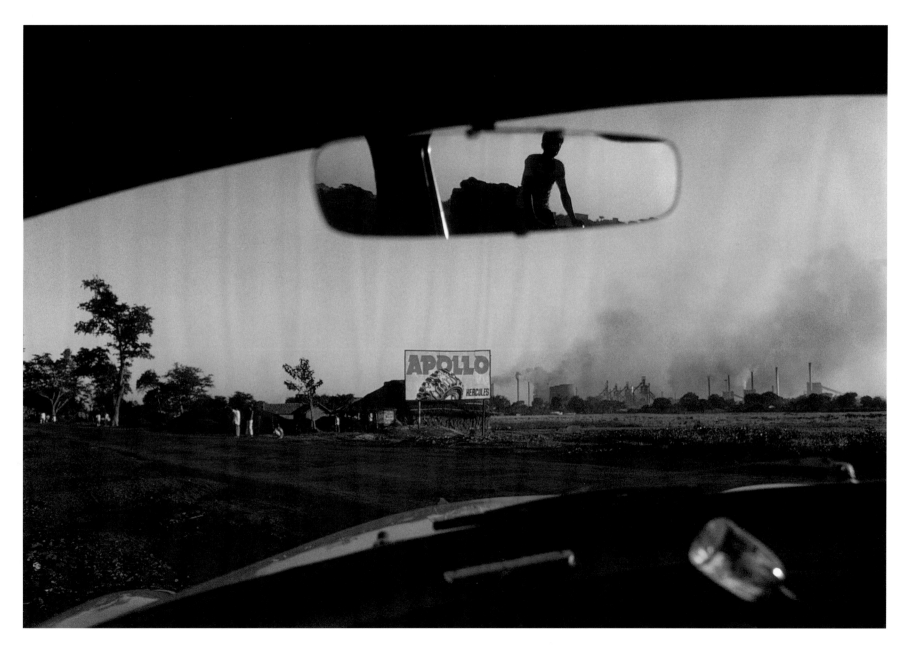

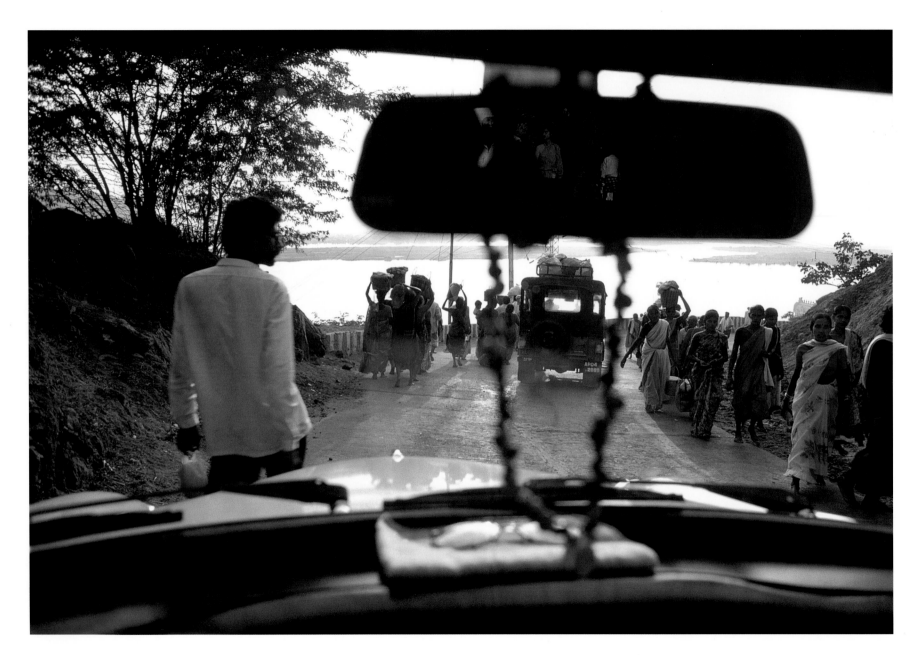

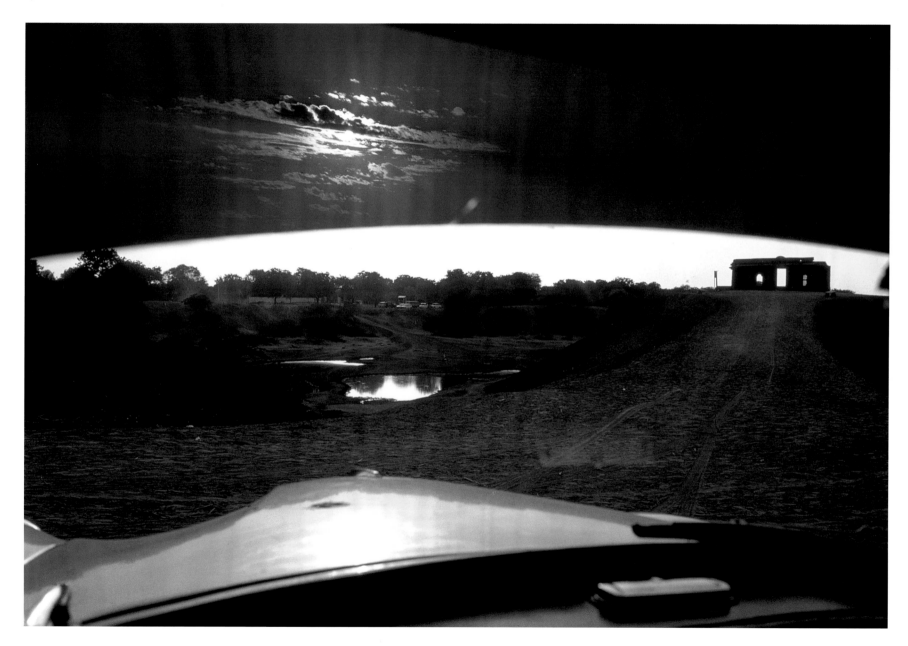

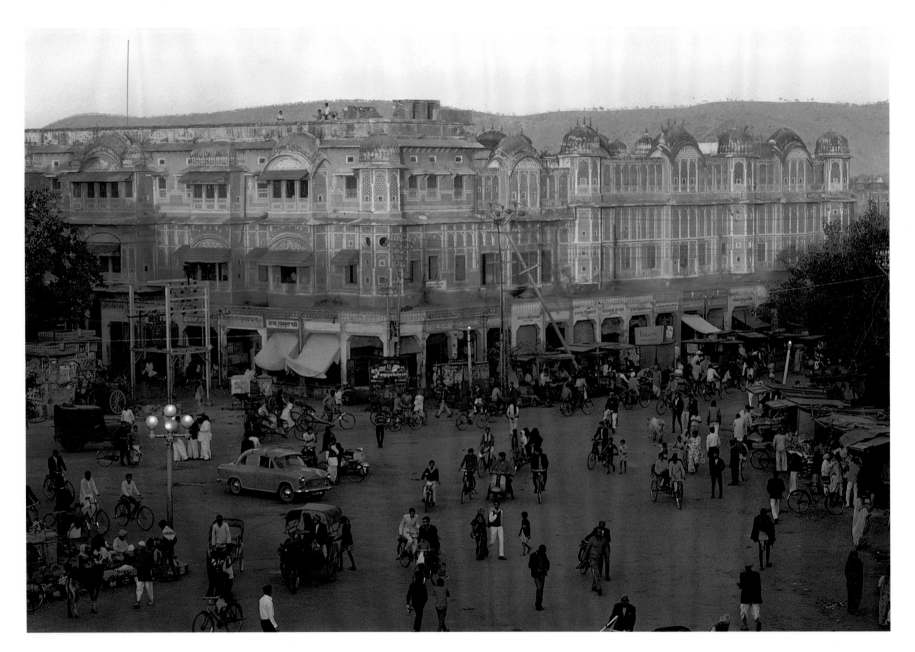

Captions

1.	location not known		1998
2.	Tamil Nadu		1996
7.	Jaipur, Rajasthan		1997
8.	Jaipur, Rajasthan		1997
9.	Jaipur, Rajasthan		1997
10.	Jaipur, Rajasthan		1997
11.	Jaipur, Rajasthan		1997
12.	Jodhpur, Rajasthan		1997
13.	Jaipur, Rajasthan		1997
14.	Jal Mahal, Jaipur, Rajasthan		1997
15.	Jaipur, Rajasthan		1997
16.	Rajasthan		1997
17.	Nahargarh Fort, Jaipur, Rajasthan		1997
18.	Jaigarh Fort, Jaipur, Rajasthan		1997
19.	Red Fort, Agra, Uttar Pradesh		1997
20.	Tamil Nadu		1998
21.	Jalandhar, Punjab		1988
22.	New Delhi		1997
23.	New Delhi		1997
24.	Agra, Uttar Pradesh		1997
25.	Agra, Uttar Pradesh		1997
26.	New Delhi		1997
27.	North India		1997
28.	Tirupati, Andhra Pradesh		1997
29.	Grand Trunk Road, Haryana		1993
30.	Tirupur, Tamil Nadu		1994
31.	Ahmedabad, Gujarat		1997
32.	Jaipur, Rajasthan		1997
33.	Karnataka		1995
34.	Rajasthan		1997
35.	Rajasthan		1997
37.	Rajasthan		1997
38.	Yercaud, Tamil Nadu		1994
39.	Karnataka		1995
40.	Budda Badan, Karnataka		1994
41.	Munnar, Periyar Road, Kerala		1995
42.	Tamil Nadu		1995
43.	Ooty, Tamil Nadu		1995
44.	Andhra Pradesh		1996
45.	Rameswaram, Tamil Nadu		1994
47.	Tamil Nadu		1998
48.	Chennai, Tamil Nadu		1995
49.	Golconda, Andhra Pradesh		1995
50.	Kerala		1995
51.	Kerala		1995
52.	Andhra Pradesh		1996
53.	Grand Trunk Road, West Bengal		1985
55.	New Delhi		1999
56.	Calicut, Kerala		1984
57.	Hyderabad, Andhra Pradesh		1995
58.	Andhra Pradesh		1996
59.	Goa		1996
60.	Pondicherry		1998
61.	Jaipur, Rajasthan		1997
62.	Bangalore, Karnataka		1995
63.	Mahabalipuram, Tamil Nadu		1996
64.	New Delhi		1999
65.	Chennai, Tamil Nadu		1995
66.	Sravanabelagola, Karnataka		1995
67.	Bidar Fort, Karnataka		1995
68.	Kerala		1998
69.	South India		1998
70.	Punjab		1998
71.	Grand Trunk Road, Punjab		1988
72.	Trichur, Kerala		1985
73.	Yanam, Pondicherry		1996
75.	Rajasthan		1997
76.	Jodhpur, Rajasthan		1997
77.	Tamil Nadu		1998
78.	Gujarat		1997
79.	Ahmedabad, Gujarat		1997
80.	Modera, Gujarat		1997
81.	Gujarat		1997
82.	Rajasthan		1997
83.	Gujarat		1997
85.	Kolkata, West Bengal		1988
86.	Kolkata, West Bengal		1985
87.	Kolkata, West Bengal		1987
88.	Uttar Para, West Bengal		1996
89.	Uttar Para, West Bengal		1996
90.	Badami, Karnataka		1995
91.	Kerala		1995
92.	New Delhi		1988
93.	New Delhi		1999
95.	Kumbh Mela, Allahabad, Uttar Pradesh		1977
96.	location not known		1997
97.	location not known		1998
98.	Mughalserai, Uttar Pradesh		1991
99.	Srinagar, Kashmir		1980
100.	North India		1997
101.	Gujarat		1997
103.	New Delhi		1981
104.	Jodhpur, Rajasthan		1997
105.	Agra, Uttar Pradesh		1999
106.	Bundi, Rajasthan		1997
107.	Bundi, Rajasthan		1997
108.	Amer, Rajasthan		1997
109.	New Delhi		1981
111.	Kerala		1998
112.	Badami, Karnataka		1995
113.	Jaipur, Rajasthan		1997
114.	South India		1998
115.	Gujarat		1997
116.	Grand Trunk Road, Durgapur, West Bengal		1988
117.	Grand Trunk Road, Durgapur, West Bengal		1988
118.	Andhra Pradesh		1996
119.	Modera, Gujarat		1997
120.	Jaipur, Rajasthan		1997

Acknowledgements

I wish to express my deep gratitude to my father's friends who have extended their warm encouragement and support to me since his death. All, in one way or another, contributed to make his work live on:

Ilan and Alka Averbuch, Neale Albert, Sherry Barbier, Caroline Barbey, Bruno Bardèche, Susan Benn, Milo Beach, Akeel and Carol Bilgrami, Anand and Neera Bordia, Francine Boura, Regine Daric, Gwen Darien, Jackie Darien, Zette Emmons, Maria and Lee Friedlander, Moni Gupta, Gargi Gupta, Amitav and Debbie Ghosh, Hudson, Alfio and Catherine Innocenti, Dharmendhar Kanwar, Arif and Farida Khan, Glenn and Susan Lowry, Joseph and Caroline Lelyveld, Partha and Swasti Mitter, Ray and Bulbul Pillai, Bruce and Lucinda Palling, Ram Rahman, Sukanya Rahman, Thomas and Anna Roma, Nadine Saunier, Mahendra Sinh, Menaka Singh, Meenakshi and Chandra Vijai Singh.

I also wish to thank my mother, Anne de Henning, for the energy and passion she puts in to preserving and promoting my father's legacy.

Devika Singh

Phaidon Press Limited
Regent's Wharf
All Saints Street
London N1 9PA

Phaidon Press Inc.
180 Varick Street
New York, NY 10014

www.phaidon.com

First published 2002
© 2002 Phaidon Press Limited
Photographs and text
© 2002 Succession Raghubir Singh

ISBN 0 7148 4211 7

A CIP catalogue record is available for this book
from the British Library.

Printed in Hong Kong